IMAGES
*of America*

# CHEYENNE
# FRONTIER DAYS

IMAGES
*of America*

# CHEYENNE
# FRONTIER DAYS

Starley Talbott and
Linda Graves Fabian

ARCADIA
PUBLISHING

Published by Arcadia Publishing
Charleston, South Carolina

Printed in the United States of America

Library of Congress Control Number: 2012944907

For all general information, please contact Arcadia Publishing:
Telephone 843-853-2070
Fax 843-853-0044
E-mail sales@arcadiapublishing.com
For customer service and orders:
Toll-Free 1-888-313-2665

Visit us on the Internet at www.arcadiapublishing.com

*To the countless number of folks who dreamed of a celebration honoring the spirit of the West, and to those who have kept the dream alive for more than a century.*

# CONTENTS

# ACKNOWLEDGMENTS

The authors say "hats off" to the staff of the Cheyenne Frontier Days™ Old West Museum for providing loving care to the legacy of the world's greatest rodeo. Special thanks go to museum director Amiee Reese for allowing the authors to utilize the collections, to curator Michael Kassel for guiding us through the precious photographs and providing us insight into the world of rodeo, and to intern Libby Szott for painstakingly scanning the photographs from the museum collection. It was a daunting task for the authors to choose the images for this volume from the thousands of outstanding photographs. We also admire and appreciate rodeo photographers everywhere for risking life and limb to capture some of the finest action photographs available. Special thanks go to photographers Randy Wagner and Jim Lynch for granting permission to use their nationally renowned photographs. Thanks to the Cheyenne Frontier Days™ staff, especially Dan Cheney, chief executive officer; J.D. McGee, retail operations manager; and to the thousands of volunteers who contribute to the yearly success of the event. Our appreciation also goes to the staff at the Wyoming State Archives, especially Suzi Taylor and Cindy Brown; and the staff of the American Heritage Center at the University of Wyoming, especially Susan Gilmore. We thank our editor at Arcadia Publishing, Amy Kline, for her support and guidance; and our husbands, Beauford Thompson and Joe Fabian, for assistance in ways too numerous to mention.

Unless otherwise noted, all images appear courtesy of the Cheyenne Frontier Days™ Old West Museum (OWM).

# INTRODUCTION

Near the end of the 19th century, the West had already been won and the frontier was considered closed. But the wild and wooly West still held a fascination for many people. Farms and ranches dotted the plains, and towns and cities provided culture and commodities. Some folks in Cheyenne, Wyoming, were looking for a way to celebrate the Western way of life and sustain economic growth.

Cheyenne was founded in 1867 as a tent town along the tracks of the Union Pacific Railroad's western expansion. At the same time, Fort D.A. Russell was created to protect railroad workers from attacks by Native Americans. Cheyenne quickly became known as a "hell on wheels" town, catering to the whims of railroad workers, miners, gamblers, saloon keepers, and military folks. The Union Pacific Railroad designated Cheyenne as a division point but did not build shops and yards there until 1889. The Cheyenne-Deadwood Stage, established in 1870, brought a new wave of folks heading to the Black Hills. Cheyenne was also influenced by many wealthy ranchers who settled the area surrounding the city and built mansions there. Cheyenne campaigned to be the capital of a new territory called Wyoming in 1869, which gave the city permanence and led to Wyoming statehood in 1890. The stage was set for the city's leaders to expand the growth and potential of Cheyenne as more than just a town along the railroad tracks. However, the railroad continued to play an important role in the city's progress.

A Union Pacific employee named Frederick Angier who was responsible for arranging excursion trains approached Col. E.A. Slack, editor of the *Cheyenne Sun-Leader*, with a unique idea in 1897. Angier had noticed a group of cowboys loading cattle on a railroad car, and he thought that would be the kind of activity others would enjoy watching. Angier suggested to Col. Slack that the city of Cheyenne might hold a festival featuring cowboys performing their usual ranch chores like riding and roping. Colonel Slack and others had visited festivals in Loveland and Greeley, Colorado, which had sparked their interest in sponsoring an event that would contribute to Cheyenne's economy and bring visitors to town.

The Cheyenne leaders formed a committee to organize a celebration, naming Warren Richardson Jr. as chairman. The committee acted quickly and set the date for a one-day event on September 23, 1897. The first program included cowpony races, a wild horse race, and pitching and bucking horse contests, with local cowboys providing livestock for the events. Folks crowded into Pioneer Park on horseback, in carriages, and in the small grandstand. The day was deemed a success, and Cheyenne Frontier Days™ was born.

The following year, a two-day event included the appearance of Sioux, Arapahoe, and Shoshone Native Americans. Buffalo Bill's Wild West Show added excitement, and a wedding ceremony was conducted at Pioneer Park. Dates for the show were later moved to August; by 1915, it was staged the last week of July; today's celebration is scheduled near the last 10 days of July.

Cheyenne's festival gained notoriety when celebrities and leaders like Pres. Theodore Roosevelt, Will Rogers, and Charles Russell came to visit. The *Denver Post*, in cooperation with the Union

Pacific Railroad, organized trains that brought thousands of visitors from Colorado, a tradition that continues. Hollywood discovered Cheyenne and, beginning in the 1920s, sent film crews and stars to the city.

In the 1930s, cowboys formed an association called "The Turtles" to make known their concerns and requests for the fair rules of rodeo, the division of prize money, and designation of champions. This organization later became the Rodeo Association of America, then the Professional Rodeo Cowboys Association.

The rodeo became so popular that, in 1919, it acquired the nickname of "The Daddy of 'Em All," because the celebration had gained a world-wide reputation and was imitated throughout the country. Eventually, the day show was judged as overly lengthy, and in 1929 a night show was added. This became a venue for specialty acts like trick-riders and Native American performers. After World War II, big-name bands like Lawrence Welk played for dances, and entertainers including Roy Rogers, Johnny Cash, Willie Nelson, Charlie Daniels, George Strait, and Reba McEntire came to perform.

Parades led off the festivities from the earliest celebrations to the present time. Currently, four grand parades attract crowds to downtown Cheyenne. On alternate days, a free pancake breakfast feeds thousands, while locals host various events throughout town.

Frontier Days moved to its present location at Frontier Park in 1908 when a new steel grandstand was erected. The grandstands have been enlarged several times. The complex, including the arena, bucking chutes, holding pens for livestock, a carnival area, vendor area, dance halls, restrooms, and parking lots, has been built entirely from profits.

Throughout the years of both world wars, Cheyenne received the government's permission to continue the celebration. During World War II, when 20,000 men were stationed at F.E. Warren Air Force Base (formerly Fort D.A. Russell), the War Department felt the event would provide an incentive for the troops and commanded that the show go on. From the beginning, the military participated in parades and performed at the rodeo grounds. In 1953, the world-famous Thunderbirds flying team staged a spectacular aerial acrobatics demonstration over the city that continues to this day.

During the Depression years, as rodeo attendance waned, local businesses sold tickets to name a rodeo queen as a goodwill ambassador. The winning group, American Legion Post No. 6, chose Jean Nimmo as the first Miss Frontier, and the second-place Kiwanis picked Patricia Keefe as lady-in-waiting. A process was instituted in 1934 to select future Miss Frontiers from college-aged daughters of pioneer families or those closely associated with the rodeo. Current candidates for Miss Frontier are chosen through an interview process. These young women serve as ambassadors traveling thousands of miles each year to promote the event.

Volunteer committees formed the foundation of Cheyenne's festival, which today includes a board of directors, the general chairman, 10 committees, and a small year-round staff including a chief executive officer. Two specialized groups consisting of longtime volunteers are the "Heels" and "W-Heels." The Heels began as a men's group performing a variety of tasks but now also include women. The W-Heels consist of women organizing the parade section featuring old-time vehicles, and they are in charge of preserving and constructing frontier costumes.

Many horse-drawn carriages and wagons were collected and stored in various locations prior to 1978, when a museum was established. A gift from the Vandewark estate provided the addition of a new wing in 1991, resulting in a showpiece building for the collection. The Cheyenne Frontier Days™ Old West Museum is sustained through admission fees, fundraising, grants, and gift shop revenue. The museum is headed by a board of directors, with a paid professional staff for management and technical services, and utilizes a host of volunteers.

Volunteers continue to be the heart and soul of Cheyenne Frontier Days,™ along with the leadership of the staff. Each year, about 2,500 volunteers don their cowboy boots and hats and come together to stage the nation's largest outdoor rodeo and Western celebration.

# *One*

# SEEDS OF A CELEBRATION

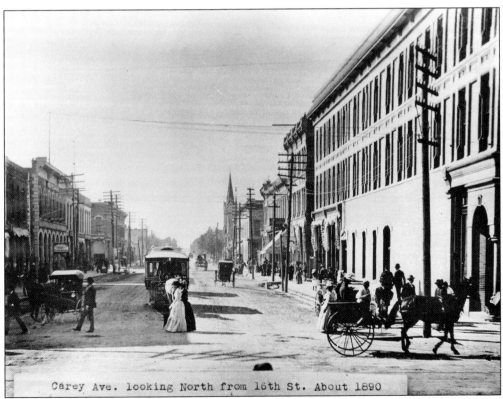

Carey Ave. looking North from 16th St. About 1890

The year 1890 saw Wyoming entering into statehood. It was seven years before the advent of Cheyenne Frontier Days,™ but already the town was prosperous and growing, thanks to the cattle barons and railroad industry that brought enterprise to the Magic City on the Plains. (Courtesy of OWM.)

Citizens who organized a frontier festival for Cheyenne chose Warren Richardson Jr., who, at the age of 33, served as the first general chairman. Richardson was a Cheyenne entrepreneur, owner of the historic Tivoli building, and a county commissioner. He was said to have been especially proud of his involvement and reminisced about his contributions to Cheyenne events until his death in 1960. (Courtesy of the Wyoming State Archives, Department of State Parks and Cultural Resources.)

Following a successful celebration, the first Frontier Committee journeyed to Fort D.A. Russell to thank Captain Pitcher for his military support. Richardson is sitting in the driver's seat, on the right, with John A. Martin (secretary) on the left. Behind them, from left to right, are committee members Granville Palmer, John L. Murray (treasurer), D.H. Holliday, Edward W. Stone, two unidentified, Clarence D. Richardson, and Col. E.A. Slack. (Courtesy of the Wyoming State Archives, Department of State Parks and Cultural Resources.)

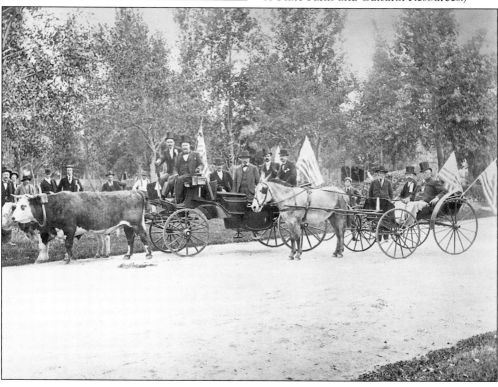

Col. E.A. Slack, editor of the *Cheyenne Daily Sun-Leader*, grasped upon an early idea laid forth by Frederick Angier, a Union Pacific Railroad passenger agent, that was sure to be an economical boost to not only the railroad, but to the town of Cheyenne. (Courtesy of the Wyoming State Archives, Department of State Parks and Cultural Resources.)

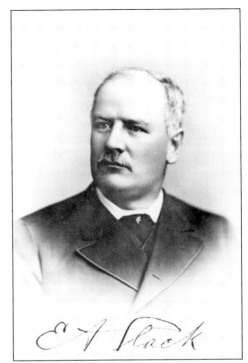

Townspeople, children, and street vendors gather to view one of the first parades. (Courtesy of the J.E. Stimson Collection, Wyoming State Archives, Department of State Parks & Cultural Resources.)

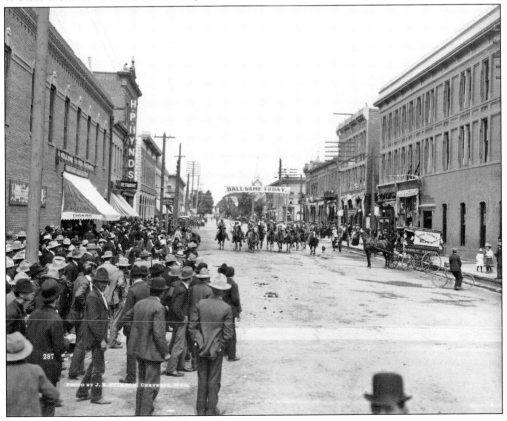

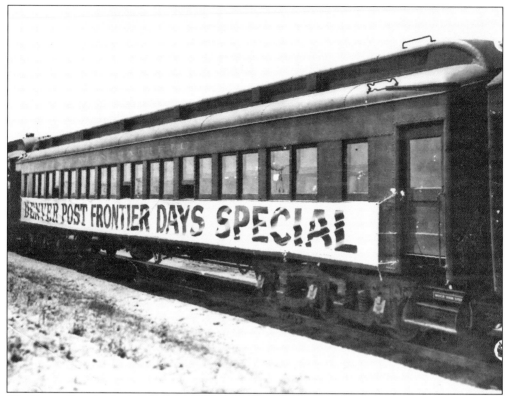

*The Denver Post* climbed on board early in support of the celebration. The newspaper and railroad executives recognized the value of transporting train passengers to a Wild West show. From the early 1900s to the present, the *Denver Post* Frontier Days Special train has brought thousands of visitors to Cheyenne. (Courtesy of OWM.)

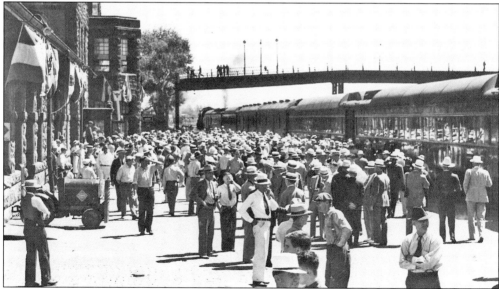

Throngs of Cheyenne residents came out to welcome their neighbors from the south in July 1936. (Courtesy of OWM.)

Headlines flashed the arrival of visitors to Cheyenne in this 1940s photograph. During World War II, the *Denver Post* trains were unavailable due to the war effort. On a few occasions, the *Denver Post* flew groups to Cheyenne on small airplanes, as shown here. The passengers are unidentified. (Courtesy of OWM.)

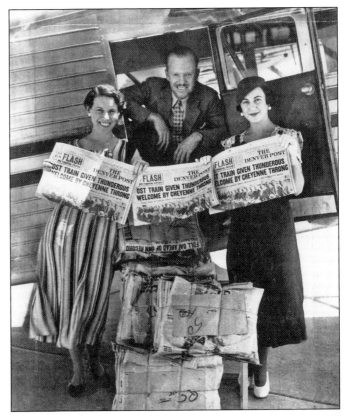

Bustling crowds of men, women, and children, on horseback, in carriages, and standing on the sidewalk, bring a sense of fanfare to the celebration. Buildings were decked out in holiday bunting, a tradition that stands to this day. W.B. Barnett, a committeeman in 1909, advertised his business by using arches to welcome visitors. (Courtesy of OWM.)

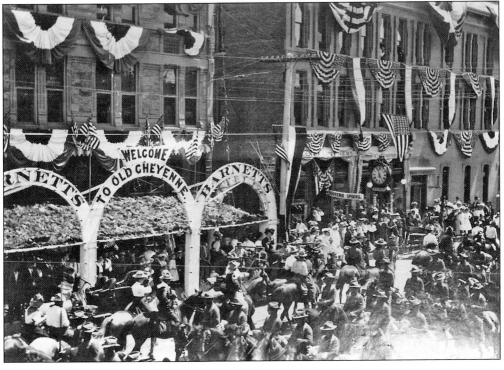

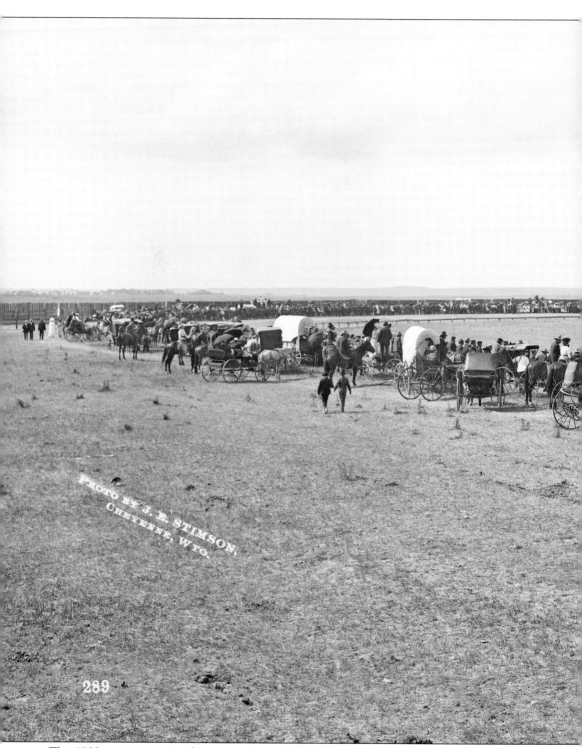

This 1902 panoramic view shows crowds watching cowboys demonstrate their riding and roping skills. People, horses, and wagons surrounded the original arena at Pioneer Park. There was no admission charge to the grounds, but some folks paid 35¢ for grandstand seats or 15¢ for bleacher

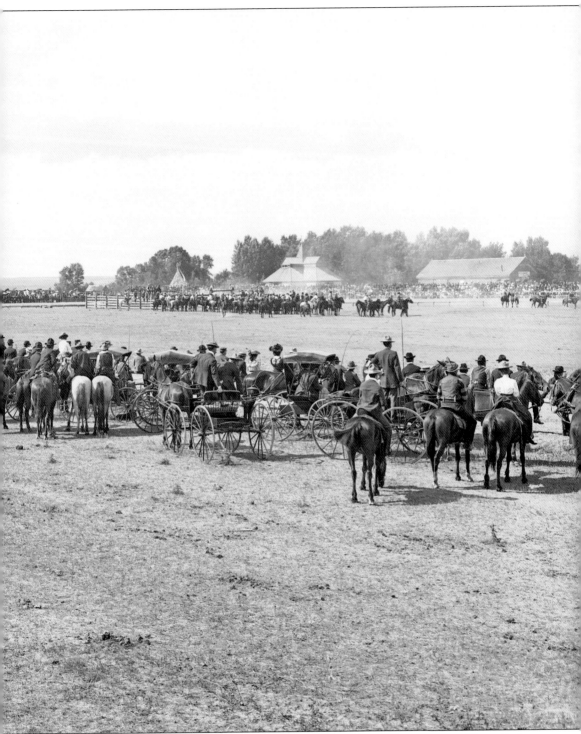

seats. (From the J.E. Stimson Collection, Wyoming State Archives, Department of State Parks and Cultural Resources.)

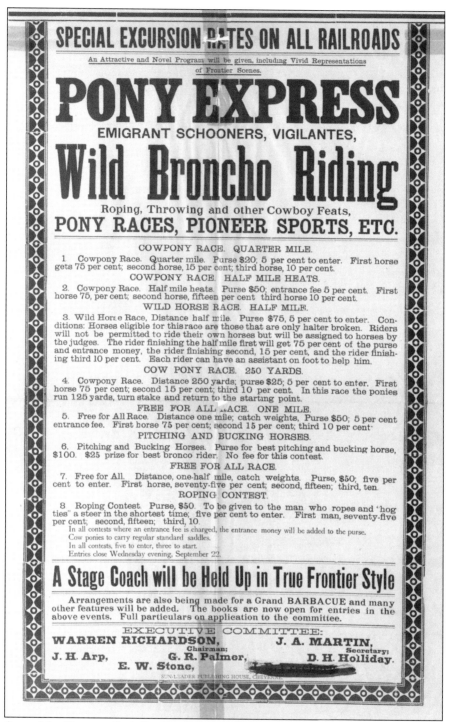

# SPECIAL EXCURSION RATES ON ALL RAILROADS

An Attractive and Novel Program will be given, including Vivid Representations of Frontier Scenes.

# PONY EXPRESS
## EMIGRANT SCHOONERS, VIGILANTES,
# Wild Broncho Riding
### Roping, Throwing and other Cowboy Feats,
## PONY RACES, PIONEER SPORTS, ETC.

**COWPONY RACE. QUARTER MILE.**

1. Cowpony Race. Quarter mile. Purse $20; 5 per cent to enter. First horse gets 75 per cent; second horse, 15 per cent; third horse, 10 per cent.

**COWPONY RACE. HALF MILE HEATS.**

2. Cowpony Race. Half mile heats. Purse $50; entrance fee 5 per cent. First horse 75, per cent; second horse, fifteen per cent third horse 10 per cent.

**WILD HORSE RACE. HALF MILE.**

3. Wild Horse Race, Distance half mile. Purse $75, 5 per cent to enter. Conditions: Horses eligible for this race are those that are only halter broken. Riders will not be permitted to ride their own horses but will be assigned to horses by the judges. The rider finishing the half mile first will get 75 per cent of the purse and entrance money, the rider finishing second, 15 per cent, and the rider finishing third 10 per cent. Each rider can have an assistant on foot to help him.

**COW PONY RACE. 250 YARDS.**

4. Cowpony Race. Distance 250 yards; purse $25; 5 per cent to enter. First horse 75 per cent; second 15 per cent; third 10 per cent. In this race the ponies run 125 yards, turn stake and return to the starting point.

**FREE FOR ALL RACE. ONE MILE.**

5. Free for All Race. Distance one mile; catch weights, Purse $50; 5 per cent entrance fee. First horse 75 per cent; second 15 per cent; third 10 per cent·

**PITCHING AND BUCKING HORSES.**

6. Pitching and Bucking Horses. Purse for best pitching and bucking horse, $100. $25 prize for best bronco rider. No fee for this contest.

**FREE FOR ALL RACE.**

7. Free for All. Distance, one-half mile, catch weights. Purse, $50; five per cent to enter. First horse, seventy-five per cent; second, fifteen; third, ten.

**ROPING CONTEST.**

8. Roping Contest. Purse, $50. To be given to the man who ropes and "hog ties" a steer in the shortest time; five per cent to enter. First man, seventy-five per cent; second, fifteen; third, 10.

In all contests where an entrance fee is charged, the entrance money will be added to the purse.
Cow ponies to carry regular standard saddles.
In all contests, five to enter, three to start.
Entries close Wednesday evening, September 22.

## A Stage Coach will be Held Up in True Frontier Style

Arrangements are also being made for a Grand BARBACUE and many other features will be added. The books are now open for entries in the above events. Full particulars on application to the committee.

### EXECUTIVE COMMITTEE:

**WARREN RICHARDSON,**
Chairman;
**J. A. MARTIN,**
Secretary;

**J. H. Arp,**      **G. R. Palmer,**      **D. H. Holliday.**

**E. W. Stone,**

SUN-LEADER PUBLISHING HOUSE, CHEYENNE

As editor of the *Cheyenne Daily Sun-Leader*, Col. E.A. Slack also owned the *Sun-Leader* Publishing House and printed the poster advertising the 1897 event. Early on, it was evident that the occasion was an opportunity to boost local businesses. (Courtesy of the American Heritage Center, University of Wyoming, from the Robert Hanesworth collection.)

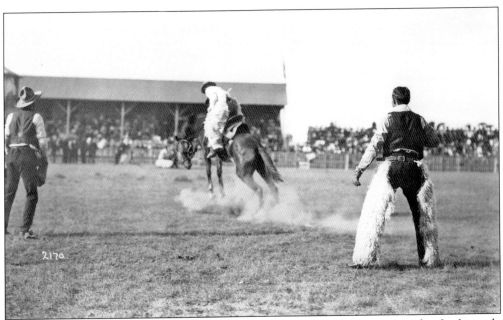

Saddle bronc riding was and still is one of the premier events at the Cheyenne rodeo. In this early photograph, an unidentified cowboy demonstrates his riding skills. Note that the rider and the cowboy off to the right are each wearing their "woolies," angora chaps that were popular in the early 1900s. (From the J.E. Stimson Collection, Wyoming State Archives, Department of State Parks and Cultural Resources.)

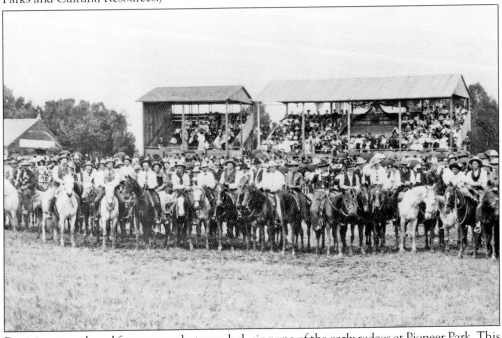

Participants gathered for a group photograph during one of the early rodeos at Pioneer Park. This tradition continued for several years when all the committee volunteers, Native Americans, and participants met in the center of the arena to celebrate. (Courtesy of Wyoming State Archives, Department of State Parks and Cultural Resources.)

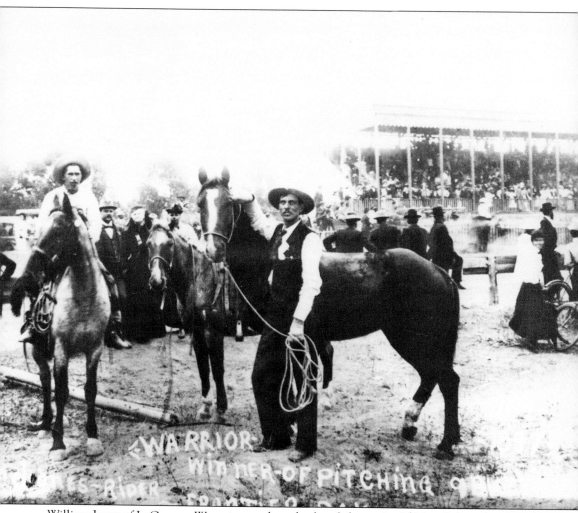

William Jones of LaGrange, Wyoming, on horseback at left, received $25 and the title of World Champion Bronc Rider in the 1897 Pitching and Bucking Horses contest. The first prize of $100 for the best pitching and bucking horse was claimed by "Warrior," shown on the right with his owner Nelson Perry, also of LaGrange. (Courtesy of the American Heritage Center, University of Wyoming, from the J.S. Palen Collection.)

# *Two*

# COWBOY UP

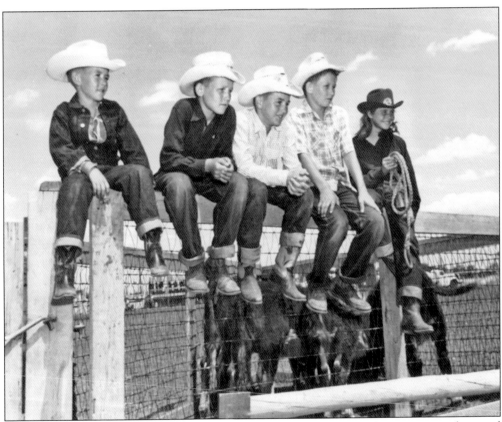

The main event at Cheyenne Frontier Days™ is the rodeo. It appears these young cowboys and a cowgirl are all dressed up for the celebration, around 1955, and they have the best seat in the house as they eagerly await the action. Perhaps they became future rodeo competitors. (Courtesy of OWM.)

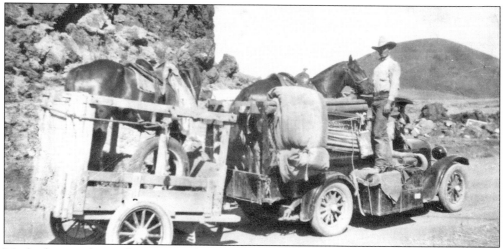

Much planning has to happen in advance of any event. Such was the case with Everett and Skeet Bowman as they prepared to haul horses to the rodeo. In 1926, their brother Dick designed and built what may have been the first horse trailer on the professional rodeo circuit. (Courtesy of OWM.)

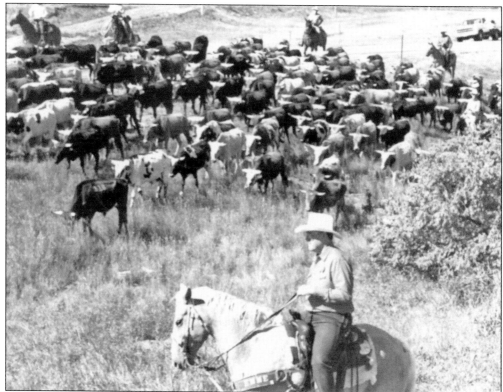

The buildup to the rodeo includes gathering livestock and driving them to Frontier Park. This cattle drive, reminiscent of the past, occurs each year. Volunteers from all walks of life participate, and people congregate along the roadway to watch. Some folks come to view this Western tradition every year, while many have never experienced it. (Photograph by Randy Wagner; courtesy of OWM.)

Hardy rodeo livestock is usually provided by stock contractors. Harry Knight was a working cowboy and saddle bronc rider from Alberta, Canada. For more than three decades, beginning in 1937, Harry was a professional rodeo stock contractor working as Gene Autry's partner in the Flying A Rodeo Company and as owner of Harry Knight and Company. Knight was a stock contractor for Cheyenne Frontier Days™ from 1959 to 1971. (Courtesy of OWM.)

Harry Vold, known as "The Duke of the Chutes," hails from Canada. He ran one of the largest stock contracting companies in North America and served as Cheyenne's contractor for 35 years through 2011. He was named to the Cowboy Hall of Fame and the ProRodeo Hall of Fame in 2009. The day-to-day operations of the Harry Vold Rodeo Company, based in Colorado, are presently managed by his daughter Kirsten. (Courtesy of OWM.)

Tradition has dominated generations of family participation in Cheyenne's frontier festival. As early as 1901, the Hirsig family name became prominent when Charlie Hirsig provided 10 steers to the event at $13 each. Pictured from left to right are arena director Beanie Hirsig; Vern Elliot, who started his career as a stock contractor around 1917; and John Bell, also a livestock supplier and arena committeeman. (Courtesy of OWM.)

Don Kensinger was instrumental in all aspects of Cheyenne Frontier Days.™ He often said that stock contractor Vern Elliot, whom he called "Mr. Rodeo," was like a father to him. This photograph shows how Kensinger, center, performed his duties as chute boss, a task that includes making sure both humans and animals are safe as cowboys mount their rides. (Courtesy of OWM.)

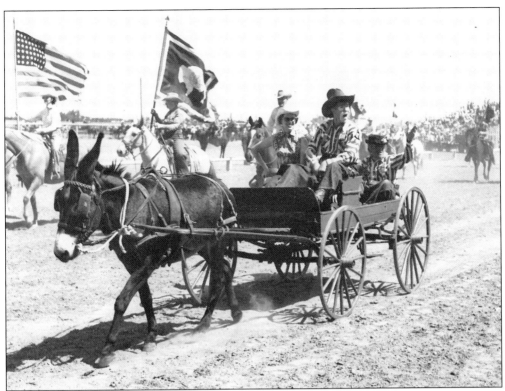

Patriotism, cowboys, cowgirls, and clowns are all part of the grand entry signifying the beginning of the rodeo. The cart in this photograph carries two unidentified rodeo clowns greeting visitors and entertaining the crowd. Clowns also perform some of the rodeo's most important and dangerous tasks of protecting bull riders from overzealous bulls. (Photograph courtesy of Warren Air Force Base from OWM.)

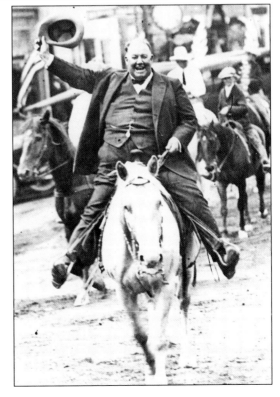

C.B. Irwin homesteaded north of Cheyenne in 1899. Irwin, larger than life itself, won Cheyenne's steer roping contest in 1900, and played a crucial role in the success of future shows. He was a cowboy, blacksmith, and Union Pacific Railroad livestock agent, and was named to the Cowboy Hall of Fame in 1975. Irwin and his brother Frank formed the Irwin Brothers' Wild West Show, touring from 1912 to 1917. (Courtesy of OWM.)

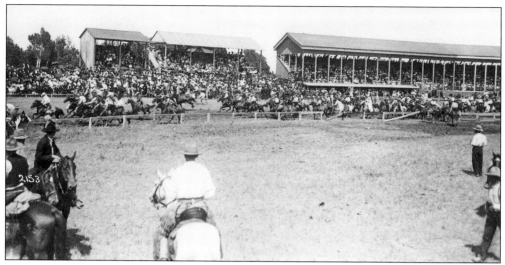

Horse racing was a prominent contest in the early days of the rodeo. There were cowpony races for the quarter-mile and half-mile, and the cowpony race dash. This 1907 photograph appears to represent the one-half-mile Free-for-All race. (Courtesy of Wyoming State Archives, Department of State Parks & Cultural Resources.)

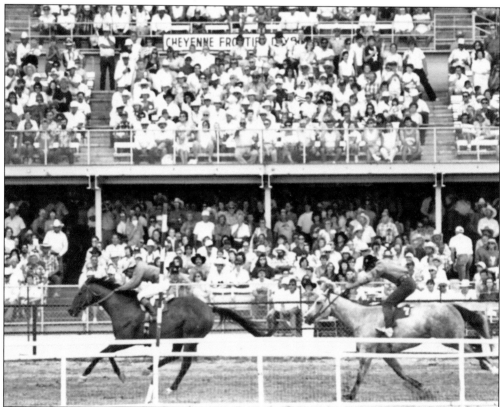

Professional horse racing later became a popular event at the Cheyenne rodeo. The unidentified riders in this c. 1972 image are heading around the track to the finish line. (Photograph by Randy Wagner; courtesy of OWM.)

24

During the early rodeos at Pioneer Park, bronc riding was called "Pitching and Bucking." Horses were saddled in the arena with the rider and helpers handling the animal. Bucking chutes were not utilized until 1919, when the first front-delivery chutes were used. Chuck Lozar, a former carpenter and fireman, appears to have discovered that finding his rhythm with the animal is crucial. (Courtesy of OWM.)

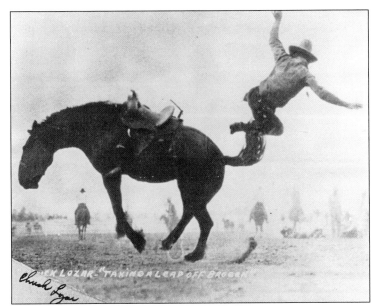

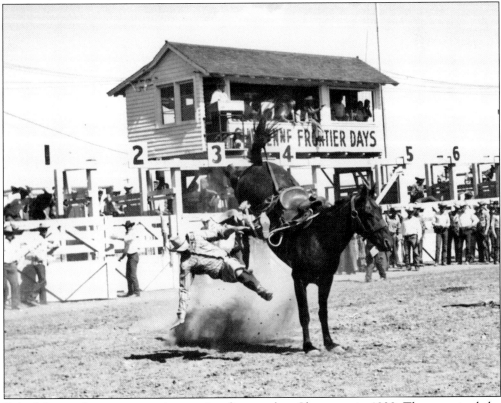

Side-delivery chutes were an innovation first used at Cheyenne in 1928. They required the assistance of several cowboys. A person in the announcer's and timer's booth fired a blank shot, signifying the end of an eight-second qualifying ride. Saddle bronc riding requires a specialized saddle with free-swinging stirrups and no saddle horn. Sometimes, unbroken horses were provided by local ranchers rather than stock contractors. (Courtesy of OWM.)

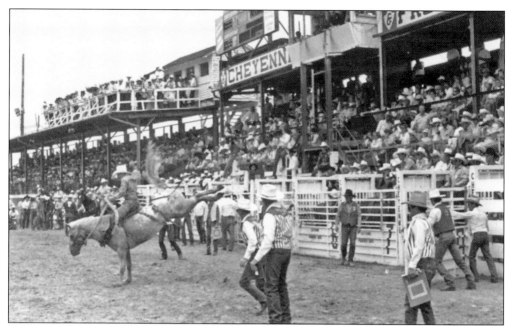

Today, the bucking stock is specifically bred for use in rodeos. Professional saddle bronc and champion bull rider Cody Lambert, pictured here, was inducted into the Texas Rodeo Cowboy Hall of Fame in 2012. After the death of his friend Lane Frost in 1989, Lambert created the protective vest that most bull riders wear today. (Photograph by Randy Wagner; courtesy of OWM.)

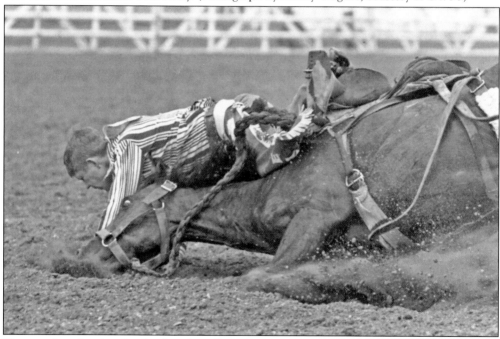

Horse and cowboy hit the dirt face-first. Onsite veterinarians make every effort to see to it that the animals are treated well. Considered to be an investment worth caring for and keeping in good health, rodeo livestock receive constant care to keep them at their high level of strength and power. (Courtesy of OWM.)

An unidentified saddle bronc contestant has mounted and signaled his readiness for the chute gate to be opened for an eight-second ride attempt. He must not touch the horse with a free hand, and the heels of his boots must be in contact with the horse, but above the horse's shoulders before its front legs hit the ground. Horse and rider each receive a possible 50-point score. (Courtesy of OWM.)

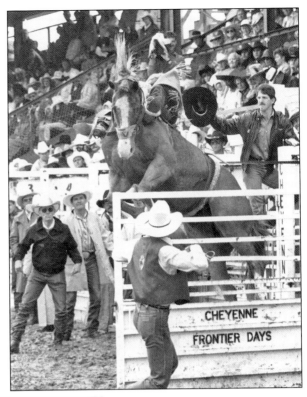

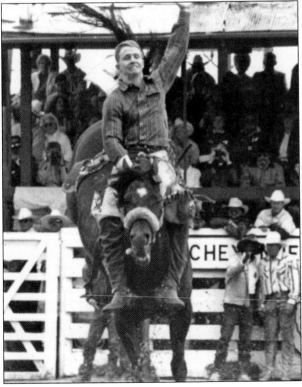

Phoenix native Ty Murray always wanted to be a cowboy. As a saddle bronc, bareback bronc, and bull rider, he won the All-Around World Championship at age 20. As a retired ProRodeo Hall of Famer, he reminds folks of "the contribution of horses to the economy, history, and character of the United States." He is a seven-time All-Around World Champion who simply wants to be remembered as a "great cowboy." (Courtesy of OWM.)

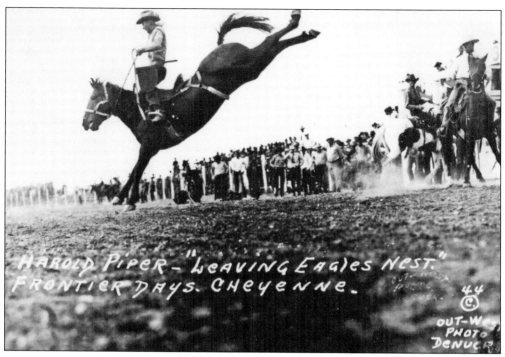

HAROLD PIPER - "LEAVING EAGLES NEST."
FRONTIER DAYS. CHEYENNE.
44 ©
OUT-WEST
PHOTO
DENVER

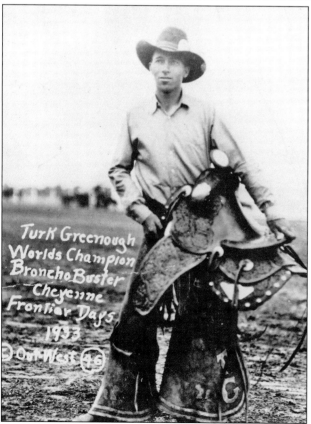

Turk Greenough
Worlds Champion
Broncho Buster
Cheyenne
Frontier Days
1933
© Out-West 46

Chugwater, Wyoming, cowboy Harold Piper is pictured on board the horse Eagles Nest at the Cheyenne rodeo in 1944. Piper rodeoed most of his life, riding in events all over the United States and Canada, though he seldom won a contest. The *Denver Post* awarded him a pair of silver spurs and the title "Hard Luck Cowboy of Cheyenne Rodeo" in the 1950s. (Courtesy of Regina Bradford.)

Turk Greenough grew up with rodeo roots. Five out of the eight children in the Greenough family chose to participate in the sport of rodeo, including his sisters Marge and Alice. In 1933, Turk was named World Champion Bronc Buster after winning the Cheyenne event on a horse named Midnight. His colorful life included being friends with celebrities, marriage to performer Sally Rand, and working as a Hollywood stuntman. (Courtesy of OWM.)

Bareback bronc riding involves mounting an untamed horse without a saddle but utilizing a leather rigging. Bareback riders need to be strong and exhibit good timing and balance. The cowboys around the chutes show camaraderie by helping each other as well as competing. The man in the striped vest judges the horse and the rider, giving each a score if an eight-second ride is achieved. (Photograph by Rusty Phillips; courtesy of OWM.)

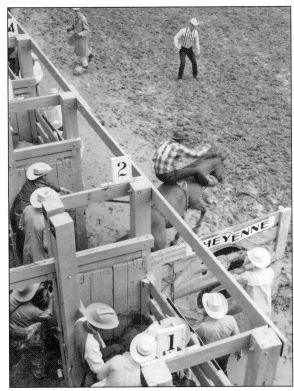

Rough landings are an everyday occurrence for cowboys in any event. This unidentified bareback bronc contestant hits the dirt face down. In this case, the horse may have scored high for its ability to quickly change direction, the horse going one way and the cowboy another, though the cowboy may or may not have received a score. (Photograph by Dusty Allison; courtesy of OWM.)

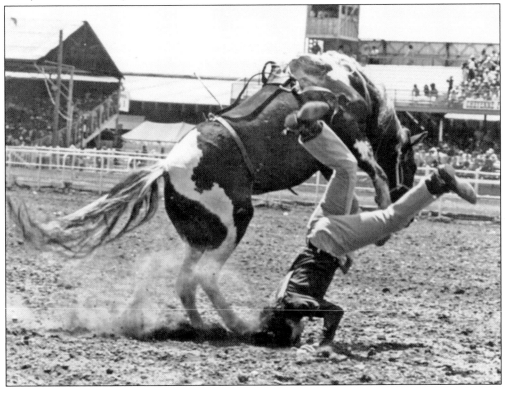

29

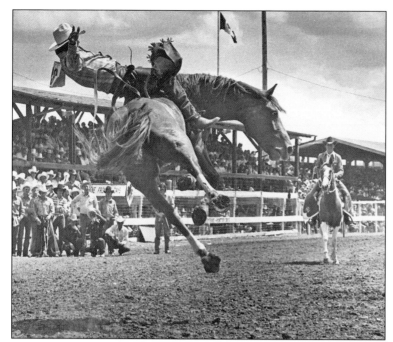

The finals rodeo on the last day of Cheyenne Frontier Days™ is the best of the best. Texas cowboy Paul Mayo was the world champion in 1966 and 1970. He is credited with perfecting the style in which the cowboy rides the bucking horse by developing the technique of moving farther back on the horse and nearly lying flat against the horse's back. (Courtesy of OWM.)

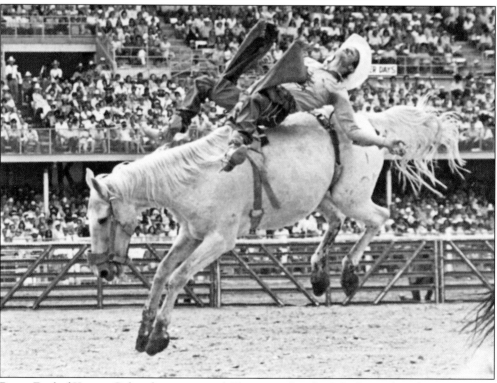

Bruce Ford of Kersey, Colorado, was named Champion Bareback Rider at the Cheyenne rodeo in 1979, 1982, and 1989. With one hand, he holds the handle on the rigging while leaning nearly straight back. The cowboy's feet remain over the point of the shoulder of the horse until its front feet hit the ground. (Courtesy of OWM.)

Chris LeDoux, shown in both photographs, wore many hats during his career as a singer, songwriter, sculptor, rodeo rider, and rancher. He competed in Cheyenne's Wild Horse Race and was a world bareback champion. To help pay expenses, he composed songs describing the cowboy way of life, often selling his albums from the back of his truck, including under the Cheyenne grandstands. He retired from rodeo in 1980, settling with his wife and five children in Kaycee, Wyoming, where he pursued his musical career. After Garth Brooks mentioned his name in a song, his musical career escalated with the sale of more than 250,000 country albums and appearances at nationwide events. LeDoux died in 2005, and his ashes were scattered in the Cheyenne rodeo arena. He was named to the Rodeo Hall of Fame and Cheyenne Frontier Days™ Hall of Fame. (Courtesy of OWM.)

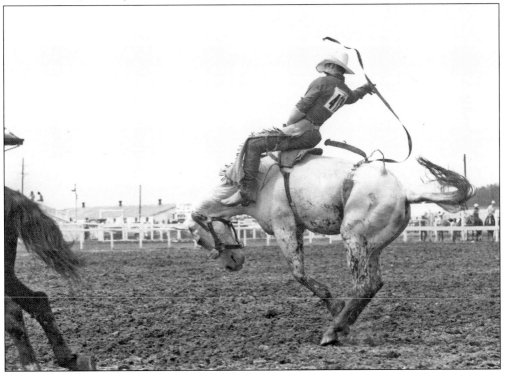

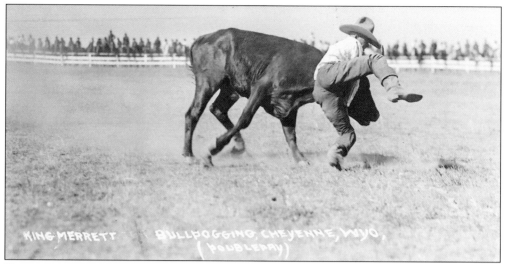

King Merritt, a name long associated with rodeo, worked on ranches in Texas before coming to Wyoming in 1912. He hired on with the Swan Land and Cattle Company before he bought a ranch northwest of Cheyenne. He participated in "bulldogging" (later called steer wrestling) at the Cheyenne rodeo, as shown in this c. 1920 photograph. A world class steer roper, he later raised horses and became active in the American Quarter Horse Association. (Courtesy of OWM.)

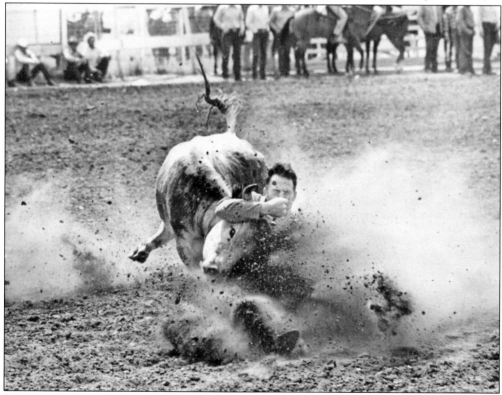

Steer wrestling is considered the quickest of rodeo contests. Originally called "bulldogging," the event was considered an exhibition act thrilling the crowd and fascinating reporters. In this image Bob Carver demonstrates the technique required to down a steer. (Courtesy of OWM.)

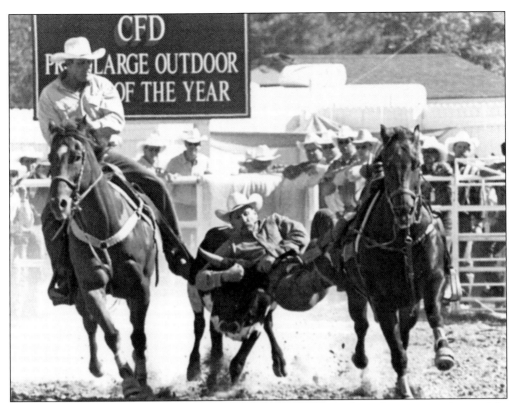

In steer wrestling, the cowboy is assisted by a hazer, whose job is to keep the steer running straight after it leaves the chute. The contest requires perfect timing, strength, agility, and unspoken signals between team members. The hazer rides on the opposite side of the steer, guiding the animal forward, with the wrestler riding close behind. At just the right moment, the wrestler leaves his horse to grab the steer by the horns and bring it to the ground. Steer wrestling (or bulldogging) began at the Cheyenne rodeo in 1915. Leon Vick is the cowboy in the photograph above, and Scott Phillips is pictured below. Note the sign in the above photograph proclaiming "CFD Large Outdoor Arena of the Year," an honor received in 1998. (Photographs by Randy Wagner; courtesy of OWM.)

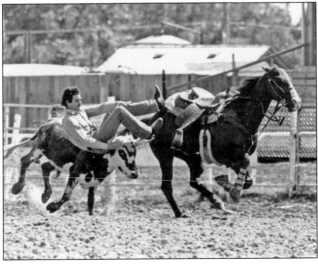

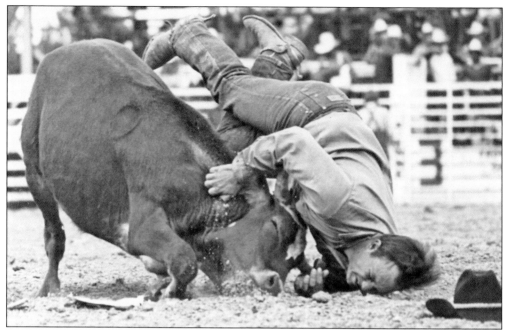

In this image, steer wrestler Kennard Windham overshot his steer and landed face down in the dirt. The contestant's hat also hit the dirt beside him. (Photograph by Randy Wagner; courtesy of OWM.)

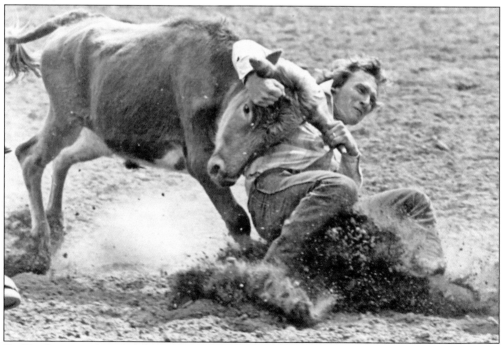

Paul Luchsinger is pictured demonstrating steer-wrestling skills. By grabbing a horn with one hand, wrapping a hand around the second horn, and planting his feet, he slowed the steer. The next step is to throw the steer down by pulling it off balance. The contestant's finishing time is marked when all four of the steer's legs leave the ground. (Photograph by Randy Wagner; courtesy of OWM.)

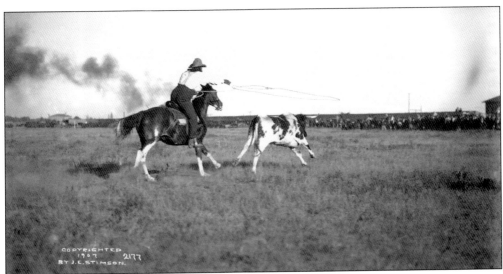

C.B. Irwin was a top-notch steer roper and won the Cheyenne title atop his horse, Custer, in 1906. Steer roping evolved from necessary ranch chores during which animals were captured to administer medicine or mark them. In a rodeo, the steer receives a head start before the cowboy is allowed to pursue him. (From the J.E. Stimson Collection, Wyoming State Archives, Department of State Parks and Cultural Resources.)

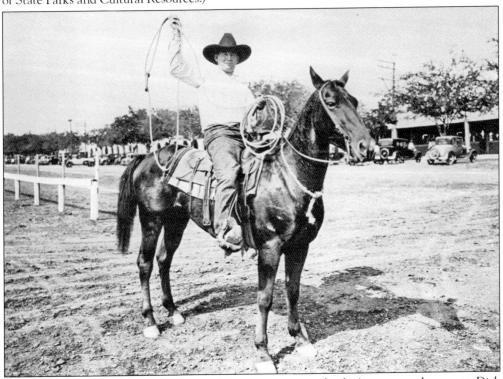

Steer roping was the way of the range and later became one of rodeo's most popular events. Dick Truitt from Stonewall, Oklahoma, is shown astride his horse displaying the tools necessary for steer roping. In 1939, he won $1,350 for his efforts at Cheyenne. He also excelled in steer wrestling, winning at Cheyenne in 1936. (Courtesy of OWM.)

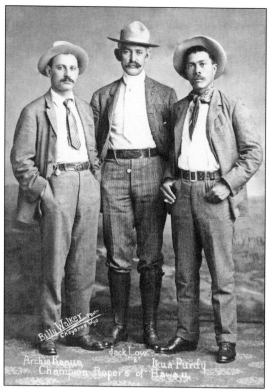

In 1908, the Cheyenne rodeo attracted steer ropers all the way from Hawaii. Archie Kaaua (left) and Ikua Purdy (right) had both been named Champion Ropers in Hawaii. They are pictured with their fellow competitor, Jack Low (center). At the Cheyenne contest, Purdy won the steer-roping event with an average time of 50 seconds. (Wyoming State Archives, Department of State Parks and Cultural Resources.)

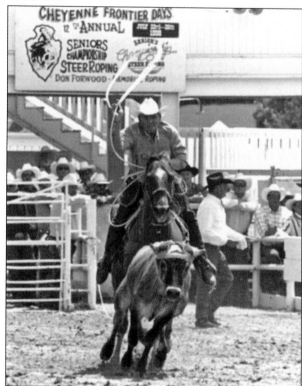

Cheyenne caters to cowboys of all ages, as shown in this 1998 photograph of the 12th-Annual Senior Championship Steer Roping Competition. Charles Jones demonstrated his skills with a rope. (Courtesy of OWM.)

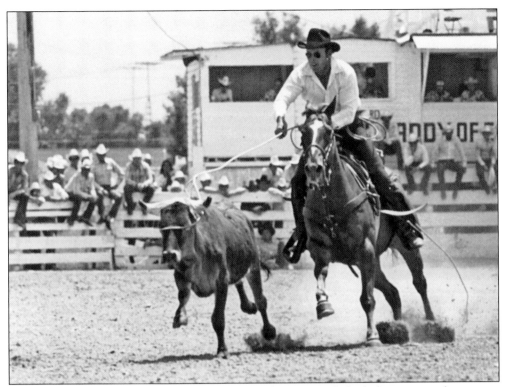

Two Wyoming cowboys, Chuck Johnson (above) and T.J. Spratt (below), demonstrate their roping skills. Steer ropers value the skills of the horses they ride and often pay large sums for a good roping horse. Johnson stated he would "rather ride a good horse and compete in a rodeo than just about anything else on earth." (Courtesy of OWM.)

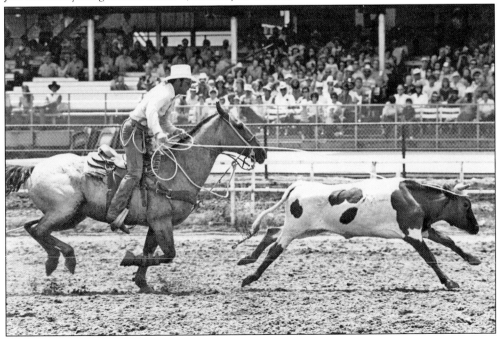

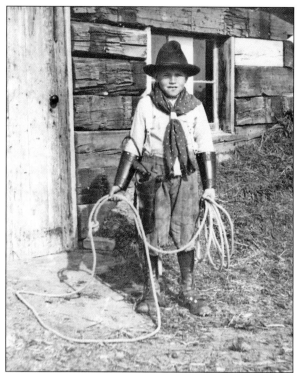

Young Turk Greenough is outfitted like a cowboy in this photograph, complete with hat, scarf, boots, and a lasso. As one of eight children, he worked on the family ranch and aspired to be a cowboy. Greenough and his sisters became known all over the United States, Canada, England, and Australia for their rodeo skills. (Courtesy of OWM.)

Oklahoma cowboy Gail Turner demonstrates the speed and skill necessary for calf roping. The goal of this timed event is for the rider to rope the calf, dismount, take the calf down, and quickly tie three legs together. Calf-roping competition evolved from necessary chores on a cattle ranch and requires the ability of a cowboy riding a well-trained and intelligent horse. (Photograph by Randy Wagner; courtesy of OWM.)

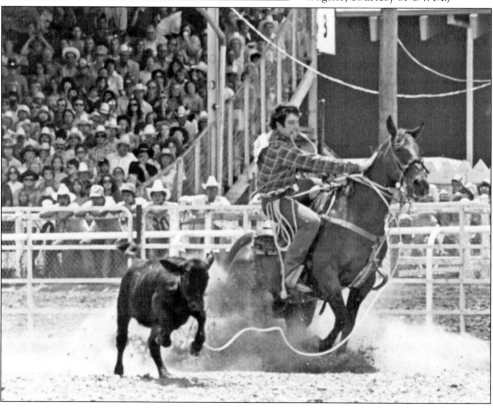

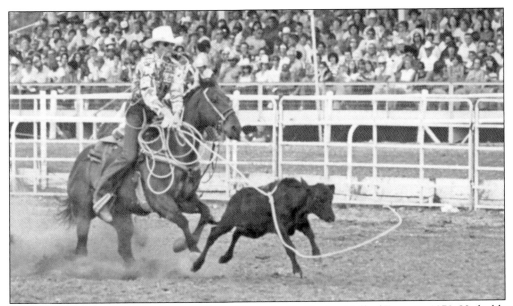

Retired calf roper Roy Cooper was inducted into the ProRodeo Hall of Fame in 1979. He holds five consecutive world roping championship titles. The calf-roping event brings in large purse winnings for exceptional cowboys. Cooper has broken records for yearly prizewinnings throughout his career and was the Cheyenne champion roper in 1978. (Photograph by Randy Wagner; courtesy of OWM.)

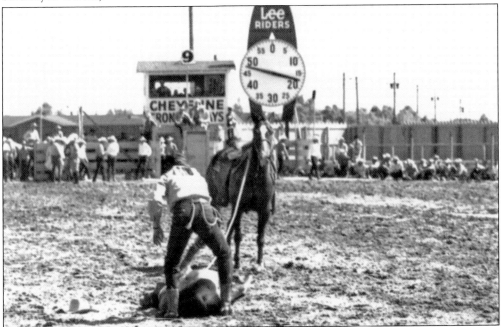

This unidentified competitor is shown getting ready to throw his hands in the air to stop the timing clock after roping a calf. The clock in the background shows the roper's time is less than 20 seconds. He must then remount his horse and move the horse forward to relax the rope. The calf must stay tied for at least six seconds for the cowboy to qualify for a place in the standings. (Courtesy of OWM.)

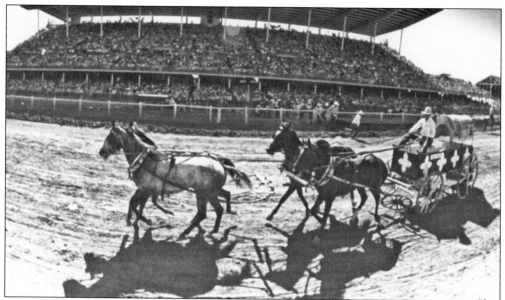

The chuckwagon races were initiated by locals in 1952. Four wagons compete in each heat by negotiating a figure-eight pattern around barrels in the arena, then racing onto the track as outriders throw a stove into the wagon, mount their horses, and take off after the wagon. Wagons and outriders must race around the track, arriving together at the end. (Photograph by Randy Wagner; courtesy of OWM.)

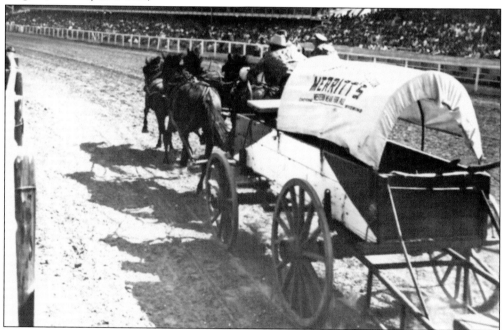

Local teams continued to compete, though Canadian teams arrived in 1953 with wagons, horses, drivers, and outriders. The majority of the Canadian teams are associated with the World Professional Chuckwagon Association. The highly anticipated event was made even more exciting by rodeo announcer Tommy "TV" Jones rooting on the teams as the wagons raced to a breathtaking finish. (Courtesy of OWM.)

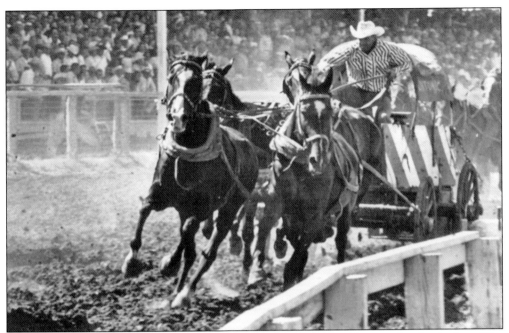

The thrilling action of chuckwagon racing was highly anticipated by crowds of onlookers. The Thoroughbred horses receive top-notch care at the hands of their owners, who normally camp out at Frontier Park to care for their animals. One owner stated, "This is a way of life, and horses are our livelihood." (Photograph by P.G. Accardo, Cheyenne Photographic Society; courtesy of OWM.)

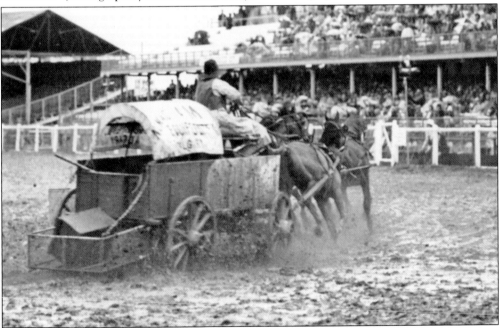

Rain and mud make the chuckwagon races even more exciting for the crowds, who jump to their feet as favorites make for the finish line. The last chuckwagon races were staged at the Cheyenne day rodeo in 1956; thereafter, the races were moved to the night show. (Photograph by Randy Wagner; courtesy of OWM.)

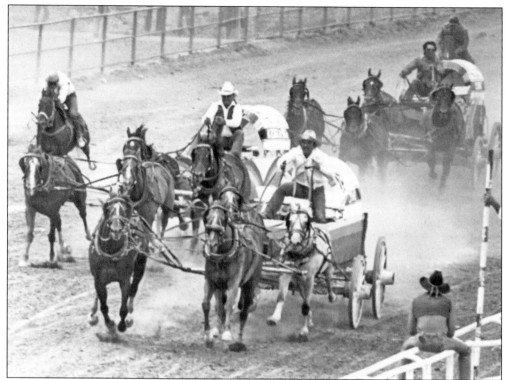

Herman Flad and his team of Canadians were among the most popular chuckwagon racers at Cheyenne. They won first place many times, as shown in this 1986 photograph. Ray Croteau's team placed second, and Ray Mitsuing's team came in third. Finish times were not recorded until 1967 and ranged from around 8 to 13 minutes. (Photograph by Randy Wagner; courtesy of OWM collection.)

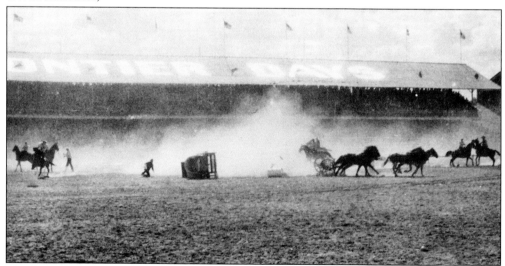

Accidents happen as the chuckwagons skid into each other while racing around the track. In this photograph, the chuckwagon has tipped over and spilled its contents, including the driver. Horses have broken free as the dust flies. Discontinued at Cheyenne in the 1990s, chuckwagon racing is a perilous (though thrilling) sport. (Courtesy of F.E. Warren Air Force Base, from OWM collection.)

An unidentified bull rider is shown leaving the chute as the crowd watches. A special handhold rope is fastened around the bull's girth with an attached bell hanging under the belly. Clanging loudly with every buck, the gear falls off when the rider releases his hold. The bulls, weighing more than a ton, sometimes charge a cowboy after the ride. (Courtesy of the Wyoming Travel Commission, from OWM collection.)

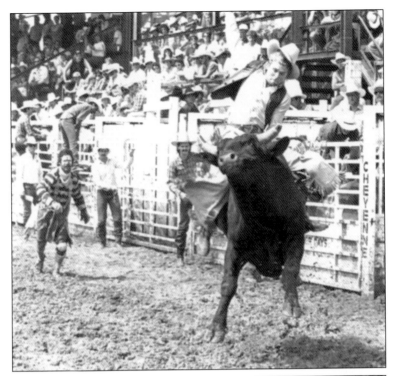

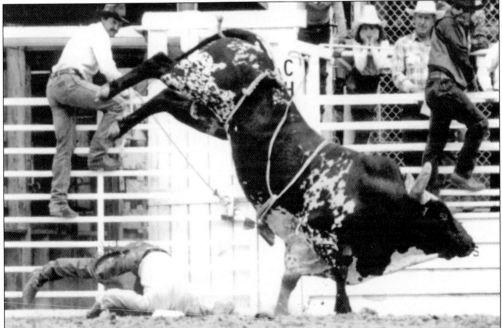

Bull rider Butch Kuhn Jr. and the famous bull Mr. T parted ways in this photograph. Mr. T, owned by the Burns Rodeo Company of Laramie, Wyoming, had a reputation for making the best bull riders in the world nervous. Only three cowboys ever rode Mr. T for the required eight seconds: Marty Staneart, Raymond Wessel, and Ty Murray. (Photograph by Randy Wagner; courtesy of OWM collection.)

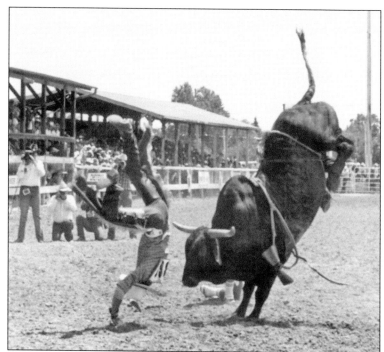

Bull rider Gerry Strom's departure from the bull sends him spinning. Rodeo photographers are nearby hoping to capture an action shot while endangering their own well-being. (Photograph by Gustafson Rodeo Photography; courtesy of OWM.)

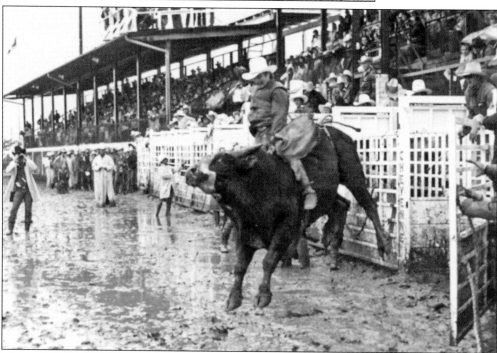

Marvin Schulte's ride became more dangerous than usual with the addition of rain and mud. Even though rain sometimes interrupts the frontier festivities in Cheyenne, the moisture is welcomed by area ranchers and farmers, who often leave their chores behind to attend the annual rodeo. Author Starley Talbott recalls fond memories of picnicking in nearby Lions Park before attending the rodeo, seated in coveted seats above the bucking chutes. (Courtesy of OWM.)

Larry Mahan competed in several rodeo events beginning at the age of 14. He won the World All-Around Rodeo Champion title for five consecutive years from 1966 to 1970 and recaptured the title in 1973. He was also the World Champion Bull Rider in 1965 and 1967. He was the subject of a film documentary, has appeared in movies, and released a music album. (Courtesy of OWM.)

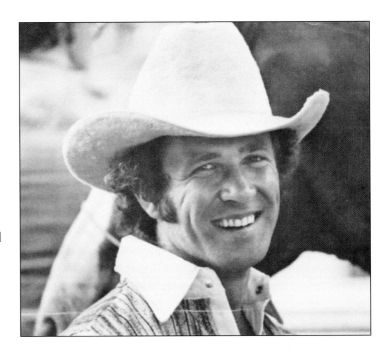

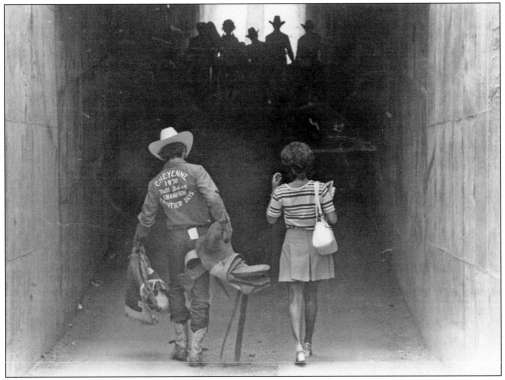

Larry Mahan, the 1970 Bull Riding Champion at Cheyenne, walks away from the arena with a companion. Following retirement from rodeo, Mahan established a line of Western wear. He currently raises horses on his ranch in Sunset, Texas. (Photograph by Pat Hall; courtesy of OWM.)

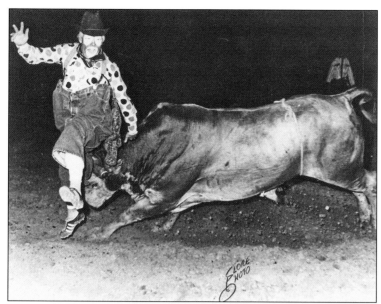

Clowns entertained rodeo crowds beginning in the early 1900s, performing between events, while many of them were also competing cowboys. Today, they work as bullfighters, drawing attention to themselves to prevent injury to a fallen rider. Jerry Olsen is pictured here. (Courtesy of OWM.)

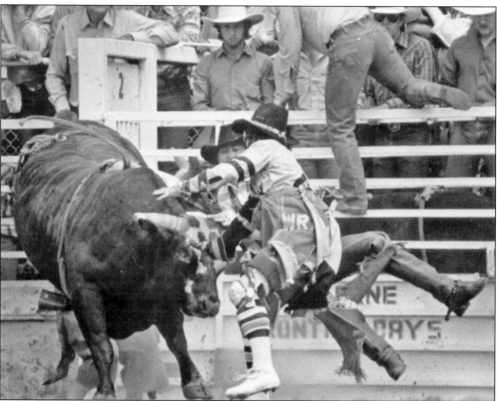

Bullfighter Rick Chatman rushes to the aid of bull rider Buddy Gulden. As a bullfighter, Chatman said that a cowboy thanking him is his biggest enjoyment and makes it all worthwhile. Injuries are part of the job, and Chatman sustained many, but he said, "Protecting cowboys is what I do, and it takes athleticism and skill, always knowing you could get hurt in the process." (Courtesy of OWM.)

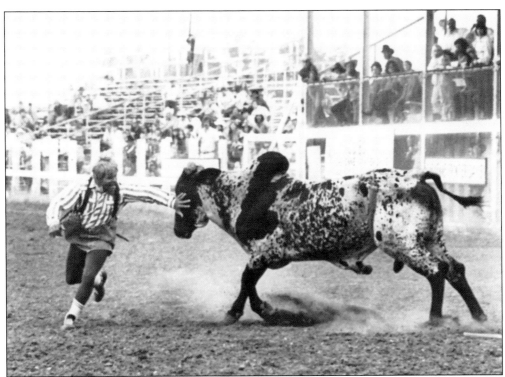

Bullfighter Wick Peth began his career in 1967. Recognized as the clown in the grey wig, denim shorts, striped shirt, and cleated shoes, Peth says he likes fighting bulls, the applause, the glory, the hours, and the money. His name is synonymous with other greats like Quail Dobbs and Bobby Romer. Peth was inducted into the ProRodeo Hall of Fame in 1979. (Courtesy of Gustafson Photography; from OWM.)

Jim McLeod and clown Wilbur Plaugher are shown "clowning around." Known as the "greatest rodeo clown of all time," Plaugher started his career in the 1940s. He played in movies, but his heart was as a cowboy and clown. He founded the Fellowship of Christian Cowboys with Mark Schricker in 1971 and was a ProRodeo Hall of Famer in 1990. The 90-year-old currently manages his ranch in California. (Courtesy of OWM.)

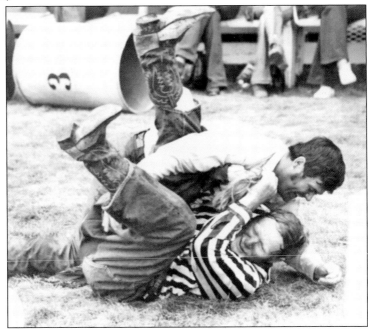

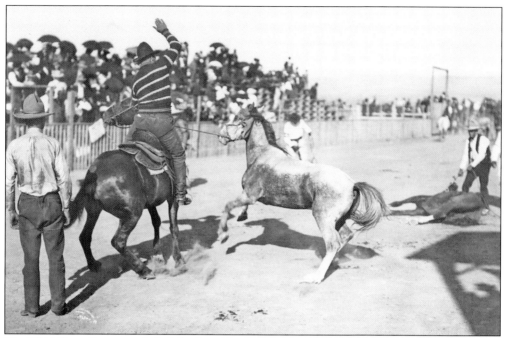

The Wild Horse Race concluded the first Cheyenne rodeo and continues to this day. The horses had never been roped, herded, or ridden and were brought from neighboring ranches. Two-person teams competed in the event until 1947, when three-person teams were instituted. The Wild Horse Race harkens back to traditions of the Old West. (From the J.E. Stimson Collection, Wyoming State Archives, Department of State Parks and Cultural Resources.)

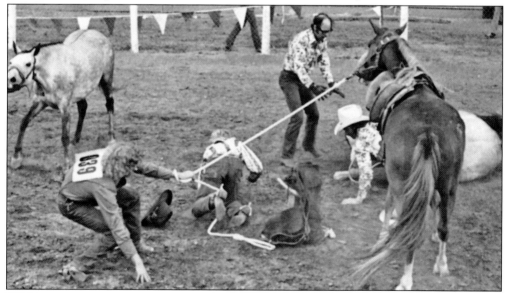

Wild horse teams constitute a mugger, shank person, and rider. All three hang onto the horse's rope halter before a signal sounds to start the race. The horse is saddled, the rider mounts, attempts to turn the horse in the correct direction, and ride once around the track. In this photograph, it appears several different teams and horses have become entangled. (Photograph by Randy Wagner; courtesy of OWM.)

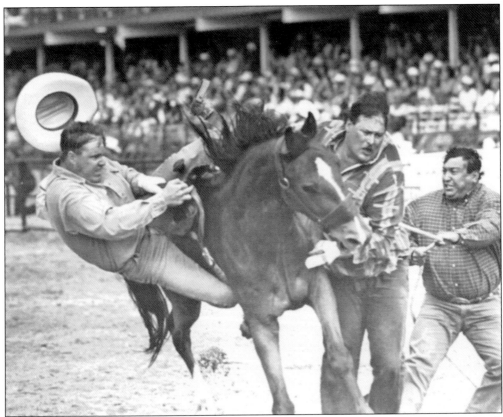

Wild horse racers are men and women of sturdy stock. The mugger, holding the horse's head, the shank man, holding the rope, and the rider all work together. The direction of travel is not known until a mounted judge fires a blank shot to begin the race and indicates the direction the rider is to follow. (Photograph by Randy Wagner; courtesy of OWM.)

There are no schools to train wild horse racers. The rider in this photograph has mounted the horse, a difficult feat in the chaos surrounding the event. If the rider is racing the correct direction and is able to round the track and cross the finish line, the rider's team in a current rodeo may win a purse of $8,500 or more—after having paid an entry fee of $400. (Courtesy of OWM.)

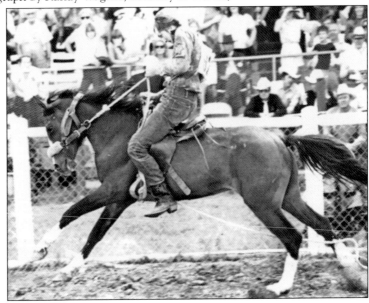

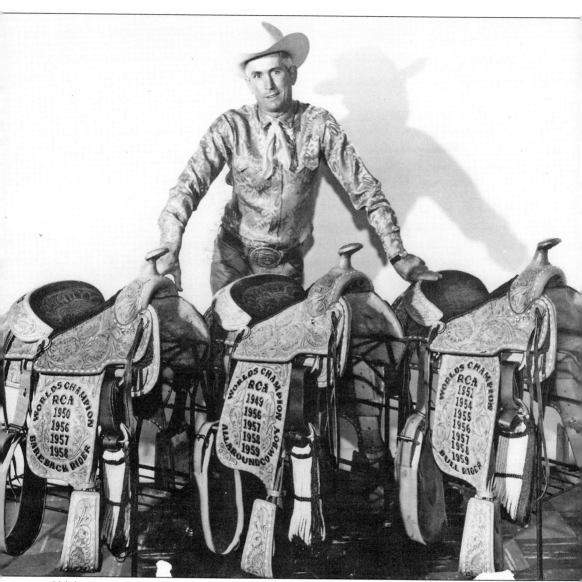

Oklahoma cowboy Jim Shoulders was 14 years old when he entered his first rodeo. Often described as one of the greatest cowboys in history, Shoulders won 16 World Championships and 10 Reserve World Championships. He took seven world titles in bull riding, four world titles in bareback riding, and five world titles as All-Around World Champion. Shoulders won the Cheyenne Frontier Days™ All-Around title four times. From his rodeo earnings, Shoulders bought a ranch in Oklahoma where he raised livestock, including rodeo stock. Rodeo cowboys often diversify their efforts, and Shoulders represented Wrangler from 1949 until his death in 2007. He was often spotted in print and electronic advertising campaigns. Known as "the Babe Ruth of rodeo," Shoulders is an inductee of the ProRodeo Hall of Fame, Texas Trail Hall of Fame, Madison Square Garden Hall of Fame, and the National Cowboy Hall of Fame. He is pictured here with three of his prizewinning saddles. (Courtesy of OWM.)

# Three

# COWGIRLS SHOW GRIT

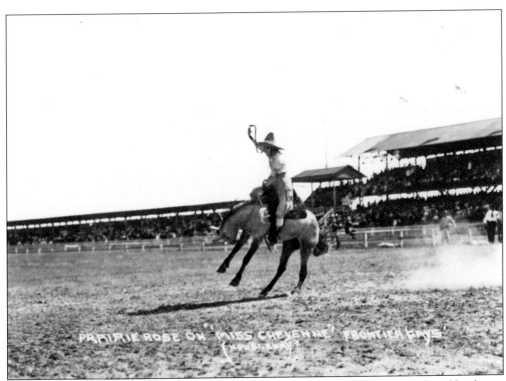

Cowgirls cut a fine picture in their costumes, with big hats and fancy boots. Prairie Rose Henderson followed the rodeo circuit as early as 1901. She participated in rodeos throughout the 1920s, rode with Wild West shows, and was queen of the Pendleton Roundup in 1910. Prairie Rose, pictured above at the Cheyenne rodeo in 1917, designed her own costumes and was often featured at state fairs and local rodeos. (Wyoming State Archives, Department of State Parks and Cultural Resources.)

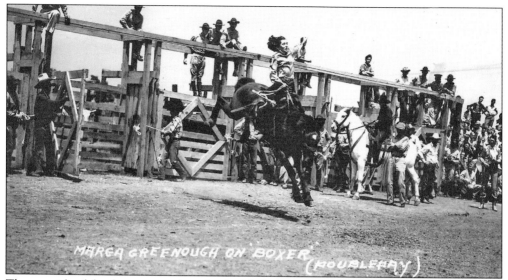

The cowgirls of the day were tough and colorful characters. While some were trick riders, many also participated in saddle bronc, bull riding, and steer roping. Marge Greenough is shown staying astride a bucking bronc named Boxer. (Courtesy of OWM.)

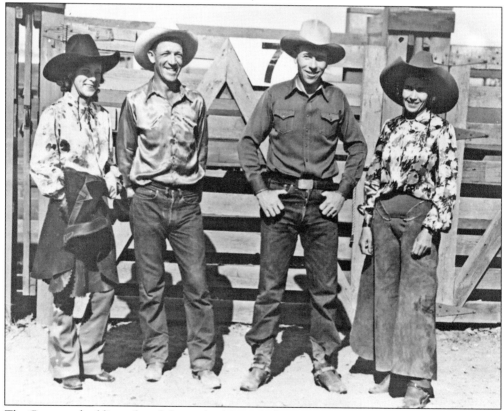

The Greenough siblings, from left to right, Marge, Bill, Turk, and Alice, were part of a large rodeo family. Turk was a familiar face around Cheyenne for many years, beginning as early as the 1920s. He won the saddle bronc contest at Cheyenne in 1933, 1935, and 1936. (Courtesy of OWM.)

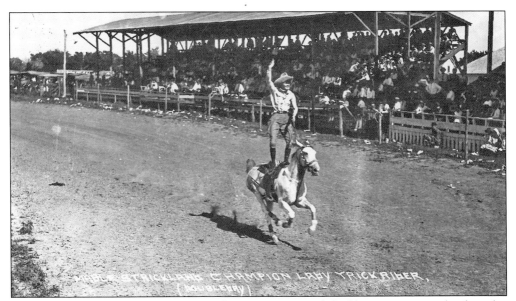

Mabel DeLong Strickland, born in 1897, became an accomplished horsewoman, trick rider, relay racer, roper, and rough stock rider. Pictured in the 1920s performing in Cheyenne, she was the champion ladies saddle bronc rider at Cheyenne in 1923 and was the cover girl on the souvenir program in 1924 and 1925. She married cowboy Hugh Strickland, and the couple followed the rodeo circuit, performed in movies, and worked as stunt riders. (Courtesy of OWM.)

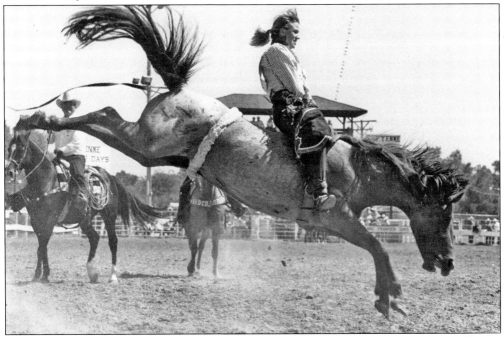

Donita Edmondson is shown aboard a bareback bronc during the Women's Professional Rodeo Association bronc and bull riding contest in 1988. Using the same stock and judges as men, the women were required to stay aboard their horse for six seconds to score a qualified ride. Several women competed in the rough stock events in 1988 and 1989 at Cheyenne. (Photograph by Randy Wagner; courtesy of OWM.)

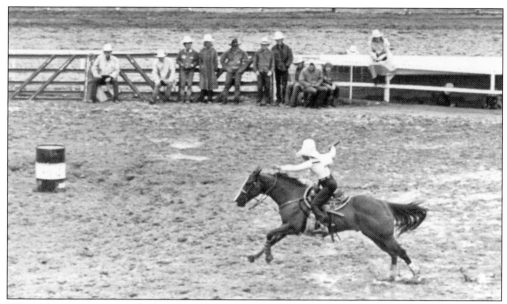

Women's events prospered when barrel racing was added to the Cheyenne rodeo in 1973. Lynn McKenzie from Texas and her horse Magnolia Missile won the Cheyenne championship in 1980 and 1981. She later designed a barrel racing saddle that led to the development of a line of equipment and tack. McKenzie and her husband, Murray, teach barrel racing at clinics nationwide. (Photograph by Randy Wagner; courtesy of OWM.)

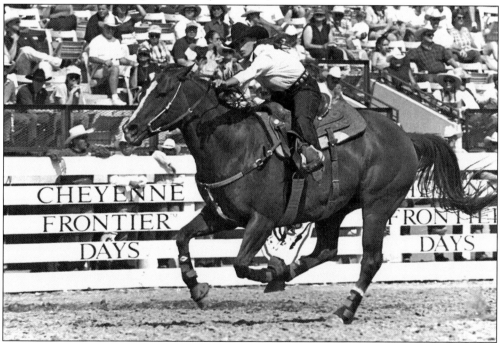

Tona Wright was the Collegiate Champion in 1984 and the National Finals Rodeo Champion Barrel Racer in 2000. Barrel racing is a timed event in which the rider attempts to complete a cloverleaf pattern around three barrels in the fastest time. Barrel racing combines the horse's athletic ability and the skills of the rider. (Photograph by Randy Wagner; courtesy of OWM.)

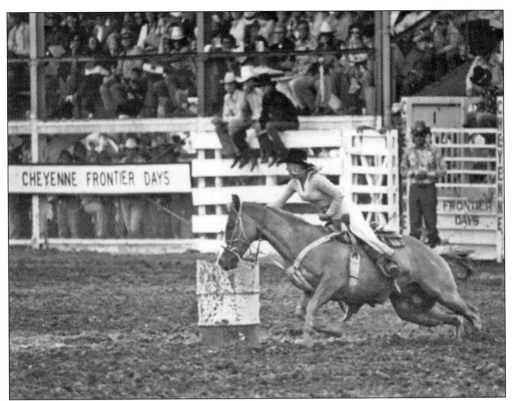

Women's Barrel Racing went on hiatus at Cheyenne for 10 years and was reinstated in 1991. The approach to the first barrel is critical. The rider must judge the speed of the horse at the right moment, so the horse is able to follow the rider's cue to make a perfect turn around the barrel. (Photograph by Randy Wagner; courtesy of OWM.)

Roz Berry demonstrated the skill required to maneuver her horse around a 55-gallon barrel, one of three placed in a triangle in the center of an arena. Cowgirls formed the Women's Professional Rodeo Association (WPRA) in 1948, giving them more credibility in the arena. The WPRA allows women to compete in various events, but barrel racing remains the most popular. (Photograph by Randy Wagner; courtesy of OWM.)

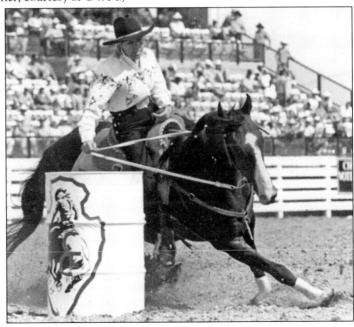

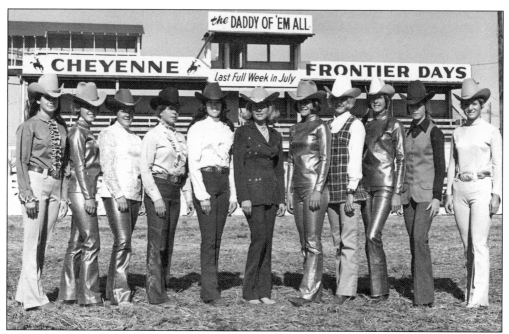

Arlene Kensinger founded the Dandies, a precision riding group for young horsewomen, in 1970. Several members of the original group posed in this photograph taken at the rodeo arena. From left to right are Lou Merritt, Sue Mueller, Chris Murphy, Candace Merritt, Patty Best, Arlene Kensinger, Janet Milam, Cynthia Lummis, Tracy Norbelt, Betsy Morris, and Heidi Merritt. (Courtesy of OWM.)

The Dandies represent Cheyenne as goodwill ambassadors. The group is composed of high school students who develop their skills through the guidance of their leaders and teachers. These young women from areas surrounding Cheyenne perform at rodeos, fairs, and other events throughout the region. These unidentified members of the team are shown with general chairman John Cole (center) in 1976. (Courtesy of OWM.)

Three unidentified members of the Dandies precision riding team carry sponsor flags during the 1982 frontier parade. Local high school girls vie for the honor of competing with the group and undergo training and practice to prepare for parades, rodeos, and other events. (Courtesy of OWM.)

The Dandies perform one of their precision riding drills during the Cheyenne Rodeo. They also ride in the Grand Entry, welcoming visitors to the rodeo and signifying that the show is ready to begin. The group is currently directed by Diane Humphrey. (Photograph by Randy Wagner; courtesy of OWM.)

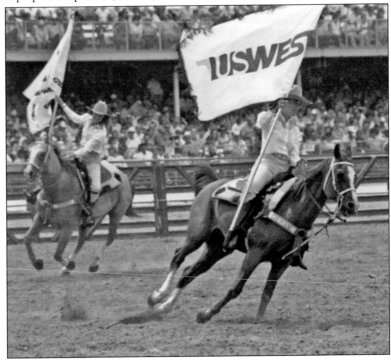

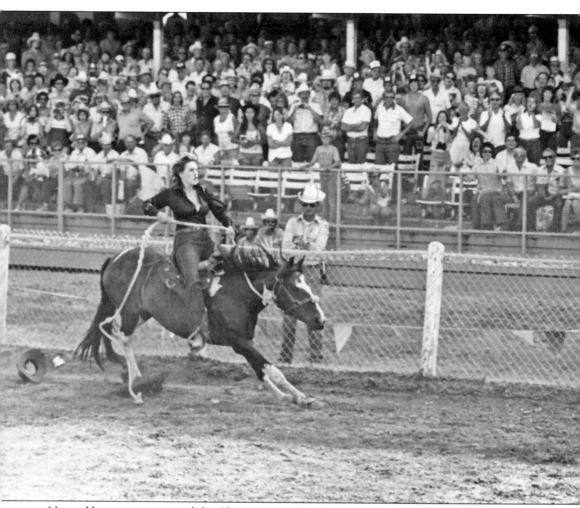

Nancy Henning entertained the Cheyenne crowd as she raced around the track during the 1981 Wild Horse Race. Though she did not win the race, she proved that women were rough-and-tough competitors. Throughout the years, several individual women and all-women teams have entered the Wild Horse Race. Closing out the rodeo as the last event of the day, the Wild Horse Race continues to be a crowd favorite. (Courtesy of OWM.)

# *Four*

# MILITARY TRADITIONS

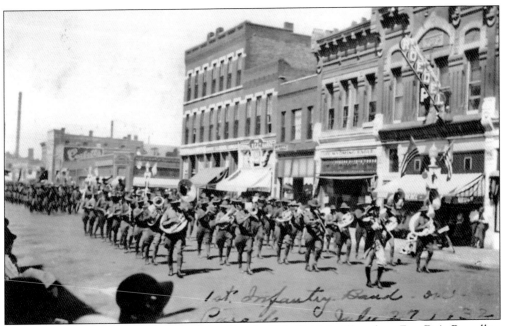

On September 23, 1897, cannons were fired by the 76th Field Artillery from Fort D.A. Russell to mark the start of the rodeo. Cannons are currently fired to signify the start of the parade. The 1st Infantry Band, shown in this photograph, marched in the parade on July 27, 1932. Support from the military continues today, with F.E. Warren Air Force Base hosting open house and Fort D.A. Russell Days. (Courtesy of OWM.)

Streets are blocked off, and throngs of people gather to view the parade in July 1954. The Army and Naval Reserve, the National Guard, and many more branches of the military are well-represented in the parade. (Photograph courtesy of F.E. Warren Air Force Base; from OWM.)

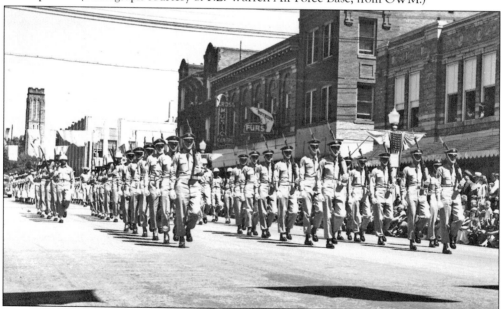

The military has participated in many Cheyenne parades and rodeo events. Infantry, cavalry, field artillery, and all branches brought their own levels of experience to the celebration. This military unit is an example of the numbers of servicemen and servicewomen who participate. (Photograph courtesy of F.E. Warren Air Force Base; from OWM.)

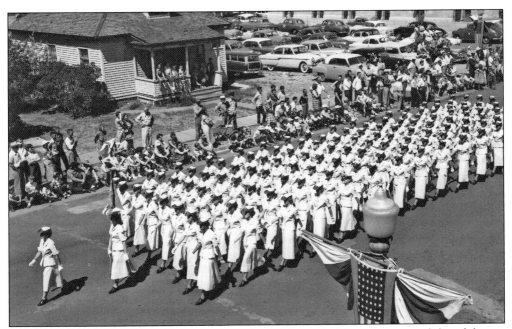

Air Force women marched with precision in the 1954 parade. Note the automobiles of the era parked behind the crowd of onlookers. (Photograph courtesy of F.E. Warren Air Force Base; from OWM.)

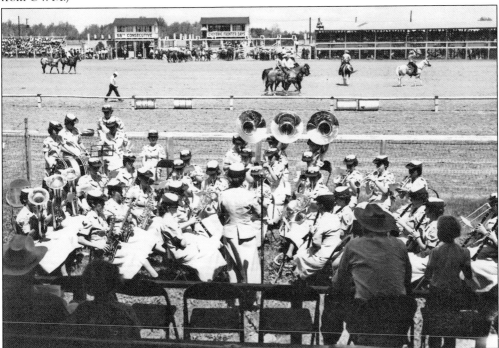

At the 58th consecutive Cheyenne Frontier Days,™ the Women's Air Force Band entertained the crowds waiting for the rodeo to begin. The rich heritage of the military participating in events shows a spectacular union of the Air Force base and the city of Cheyenne coming together each year to present an outstanding program. (Photograph courtesy of F.E. Warren Air Force; from OWM.)

R.D. Evans, a pilot with the Air Force Thunderbirds, is shown riding in the 1989 parade. Performances by the Thunderbirds, the air demonstration squadron based at Nellis Air Force Base in Las Vegas, draw thousands of viewers each year. (Photograph by Randy Wagner; courtesy of OWM.)

These unidentified pilots, members of the Air Force precision flying team, typically serve a two-year assignment with the Thunderbirds squadron, performing over 80 demonstrations a year. Each pilot logs about 1,000 hours of flight time before joining the team, a process that normally takes ten years. (Courtesy of F.E. Warren Air Force Base; from OWM.)

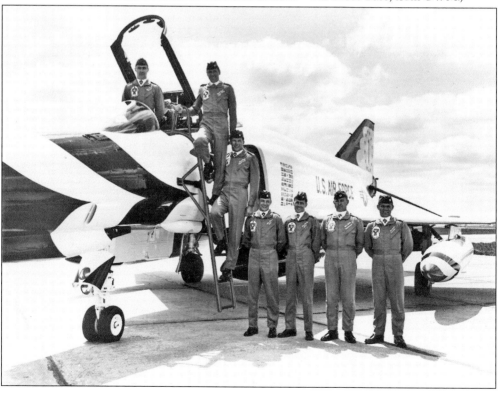

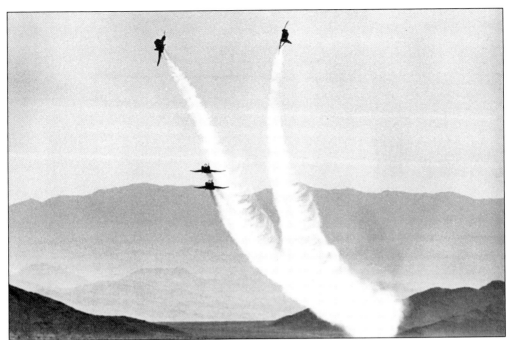

In July 1953, the Thunderbirds appeared at the Cheyenne celebration marking the beginning of an annual tradition. The team tours the United States and much of the world, performing aerobatic formation and solo flying in specially marked aircraft. The Thunderbird name is derived from a legendary creature found in the mythology of many cultures. This photograph is of the Thunderbirds at Nellis Air Force Base. (Courtesy of OWM.)

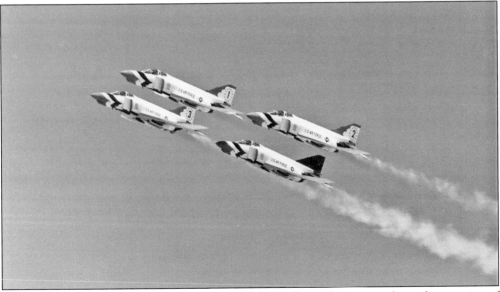

Even though the air shows are usually safe, tragedy struck in Cheyenne early on the morning of July 25, 1977, prior to the exhibition. While attempting to land, Thunderbird pilot Capt. Charlie Carter, with Sgt. Ed Foster, slammed through trees by the cowboy's campgrounds at Frontier Park, crashing into corrals and killing some animals. Both men ejected. Foster landed in the arena with minor injuries, while Carter perished. (Courtesy of OWM.)

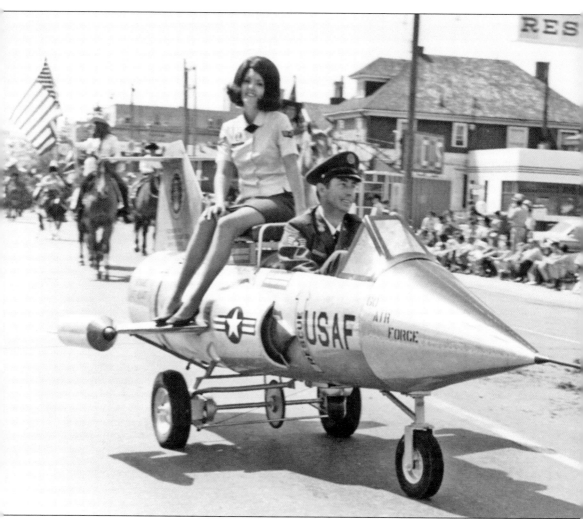

Unidentified members of the Air Force are shown during the parade riding in a special Air Force jet car. They were advertising the air show, to be held at a separate location, featuring the Thunderbirds, a group of pilots in six F-16 Fighting Falcon jets. The Thunderbird team travels the world to tell the story of the US Air Force. (Courtesy of F.E. Warren Air Force Base; from OWM.)

*Five*

# MISS FRONTIER

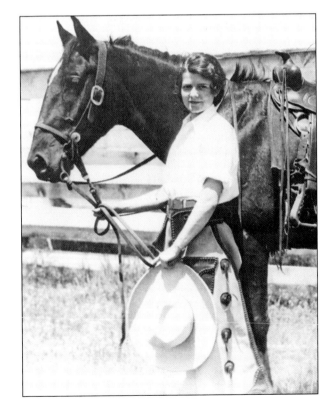

During the Depression years, as rodeo attendance waned, local businesses sold tickets to name a rodeo queen as a goodwill ambassador. The winning group, American Legion Post No. 6, chose Jean Nimmo as the first Miss Frontier, and second-place Kiwanis picked Patricia Keefe as lady-in-waiting. Nimmo stands beside a borrowed horse, wearing chaps and holding a hat won as a prize from local merchants. (Courtesy of OWM.)

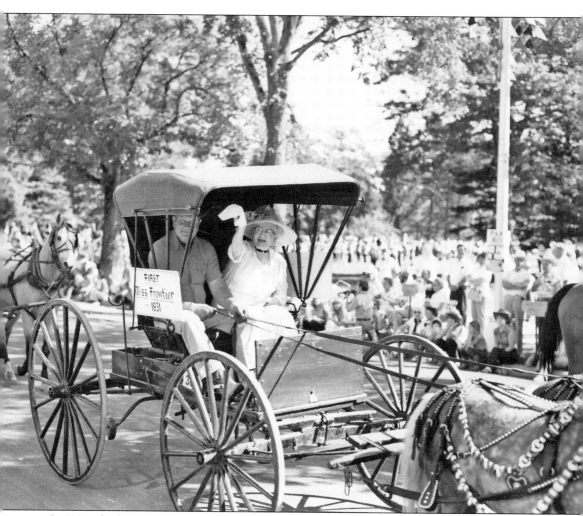

In 1981, after being named the first Miss Frontier 50 years earlier, Jean Nimmo Dubois was honored in the parade. Of her reign, she often said, "The committee didn't give me much in the way of duties. I rode in the parade and was at the park two days." In 1934, the Frontier Committee instituted a process for selecting future Miss Frontiers from college-age daughters of pioneer families, or those closely associated with the rodeo. The role of Miss Frontier has evolved through the years and today the selection is conducted through an interview process. These young women are given the opportunity to serve as ambassadors, often traveling thousands of miles each year to promote the event. (Courtesy of OWM.)

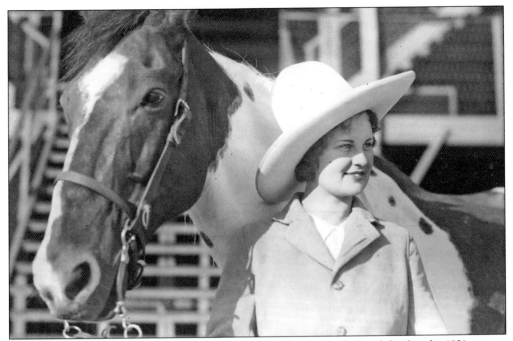

Edith Gogerty, shown with her horse and wearing a cowboy hat, had placed third in the 1931 contest and was named Miss Frontier in 1932. At that time, the lady-in-waiting did not progress to become the next Miss Frontier, though that role was soon defined. These days, a new lady-in-waiting is chosen each year to fill the role of Miss Frontier the following year. (Courtesy of OWM.)

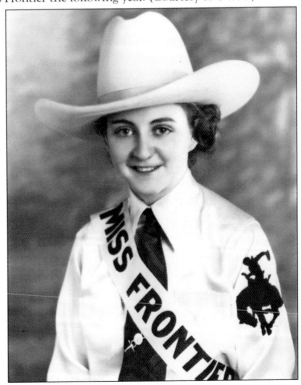

In 1934, the committee began defining the role of Miss Frontier and her lady-in-waiting as ambassadors of goodwill. In 1935, due to a suggestion by movie star Sally Rand, Miss Frontier and her lady-in-waiting began wearing white silk shirts with the bucking horse emblem on the sleeve and a white buckskin divided skirt. In 1938, Helen McCarty was named Miss Frontier. Her duties included greeting dignitaries and public relations involvement. (Courtesy of OWM.)

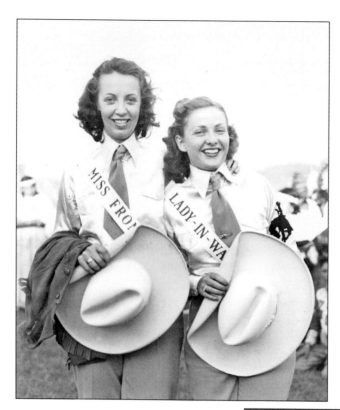

In 1940, Bette McIvor was named Miss Frontier along with Mary Ann Klett as lady-in-waiting. Wearing their silk shirts and holding ten-gallon hats, the women were all decked out as frontier ambassadors. An official coronation ceremony was originally held during the first rodeo. Today, the Coronation Ball is sponsored by the military and attended by elected officials, local dignitaries, and volunteers. (Courtesy of OWM.)

Orlene "Sis" Merritt was named Miss Frontier in 1945 and presided over all festivities during the show. The daughter of local rancher King Merritt, she was also a cowgirl in her own right. Orlene was an exhibitor at the National Western Stock Show in Denver, where she met her future husband, cowboy and rodeo clown George Mills. They traveled the rodeo circuit together for many years. (Courtesy of OWM.)

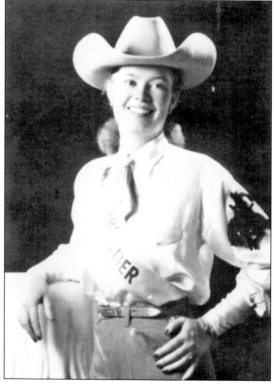

In 1947, Ann Dinneen, daughter of William J. and Anna Dinneen, was crowned Miss Frontier. She was a member of a pioneer family and the granddaughter of William E. Dinneen, who rented horse-drawn carriages in early Cheyenne. She married Clark Smith, and they raised a family of six children. She was active in Cheyenne business and civic organizations, and supported Frontier Days as a member of the W-Heels organization. (Courtesy of OWM.)

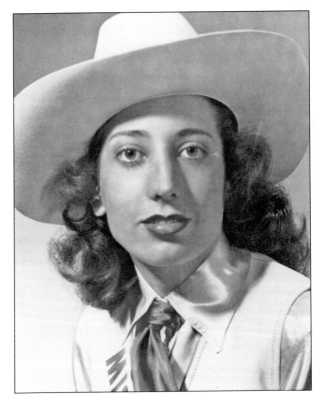

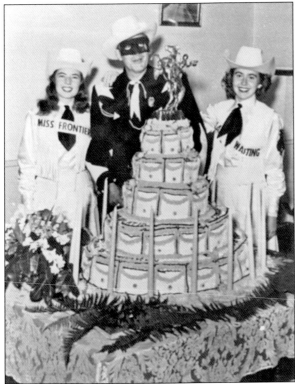

The Lone Ranger was in Cheyenne to celebrate the 15th anniversary of his radio show in 1948. Greeted by Susan Murray (Miss Frontier) and Norma Jean Bell (lady-in-waiting), the Lone Ranger wore the usual mask across his eyes and a pair of Colt 45s strapped to his hips. His appearance created national publicity for Frontier Days. (Courtesy of OWM.)

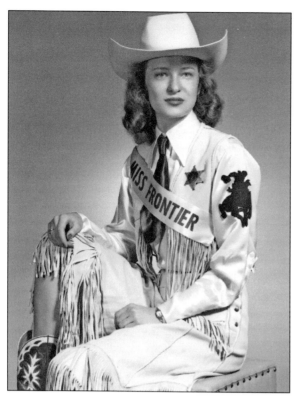

Joy Vandehei, the daughter of Earl and Flora Vandehei, grew up on a ranch north of Cheyenne. She attended the University of Wyoming and was selected as lady-in-waiting in 1949, advancing to Miss Frontier in 1950. She married Tom Kilty, and the couple resided in Cheyenne, where she was involved with many civic interests. The family donated a number of wagons, buggies, and memorabilia to the Old West Museum. (Courtesy of OWM.)

The tradition of family involvement has always been important to Cheyenne Frontier Days.™ In 1978, Joy Vandehei Kilty's daughter Deidre Ann followed in her mother's footsteps as Miss Frontier. They were the first mother-daughter pair in the history of the title. (Courtesy of OWM.)

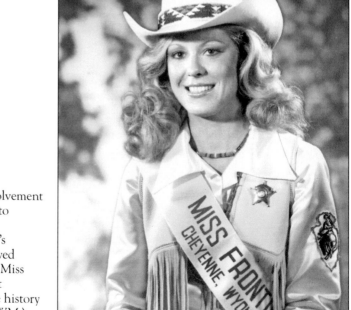

Joy Vandehei Kilty and Deidre Ann Kilty are pictured in their official Miss Frontier outfits of white buckskins. In the mid-1990s, the mother-daughter pair owned and operated the Bar X Garden and Gifts Shop, an antiques and garden center located in the old barn at the original Vandehei ranch, now at the corner of Yellowstone and Vandehei Road in Cheyenne. (Courtesy of OWM.)

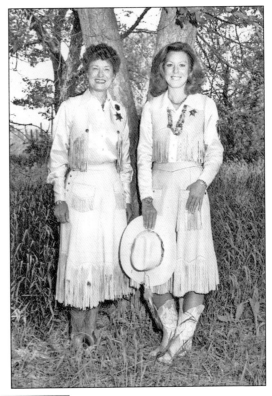

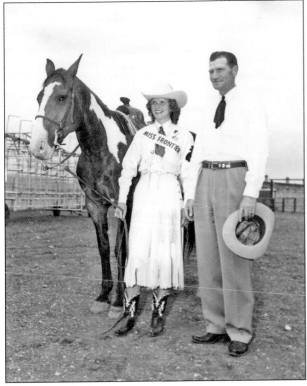

Laura Bailey, Miss Frontier in 1951, is pictured here with her father, Ed Bailey, and her paint horse. Wyoming families contribute much to the success of the frontier celebration, with descendants often following in the footsteps of their elders. The women serving as Miss Frontier needed top-notch horsemanship skills for riding in parades and rodeo grand entries. (Courtesy of OWM.)

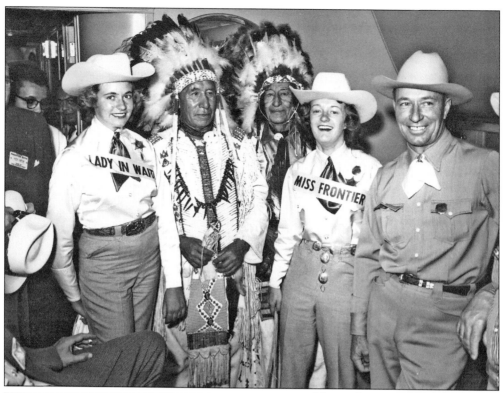

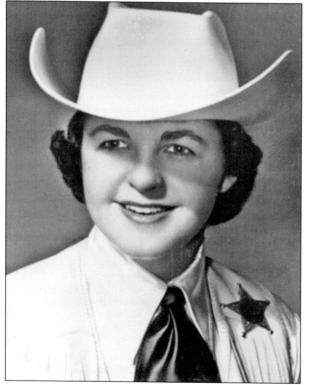

Native Americans have long been featured in the pageantry of the Cheyenne celebration. Carol Reese, lady-in-waiting; Jane Henderson, Miss Frontier; and general chairman Jim Powers are shown here in 1952 posing with two unidentified Native American representatives. (Courtesy of OWM.)

Margy Hirsig, daughter of Isabel and Fred "Beanie" Hirsig Jr., was Miss Frontier in 1954. Beginning with C.W. Hirsig as chairman of the event in 1919, the Hirsig family name has long been associated with Cheyenne's rodeo. Margy Hirsig and her lady-in-waiting, Nancy Black, were Hollywood celebrities when they appeared on the televised show *Queen for a Day* in 1954. (Courtesy of OWM.)

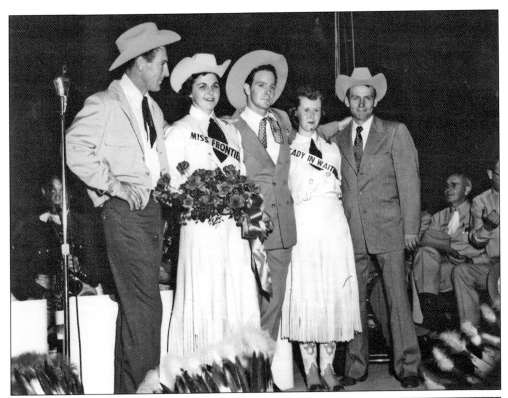

Public appearances are a major responsibility for royalty. Margy Hirsig and Nancy Black are shown with Bill Linderman (left), the Cheyenne Bareback Champion in 1945; Casey Tibbs (center); and Harry Tompkins (right). Tibbs, a cowboy from Fort Pierre, South Dakota, was the Cheyenne Saddle Bronc Champion in 1948 and was inducted into the Cowboy Hall of Fame in 1979. (Courtesy of F.E. Warren Air Force Base; from OWM.)

Jeanette Tyrrell, daughter of Ellen and Ace Tyrrell, was crowned Miss Frontier in 1958. The Tyrrell family was a well-known Cheyenne business family and long associated with the frontier celebration. Ace Tyrrell served as Frontier Days chairman, state travel commission chairman, a banker, and an automobile dealer. The Tyrrell family donated numerous items to the Old West museum collection. (Courtesy of OWM.)

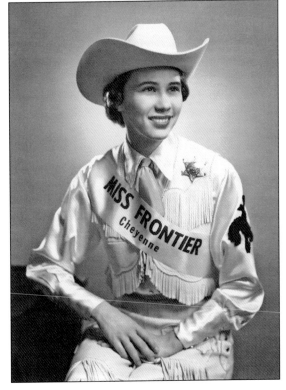

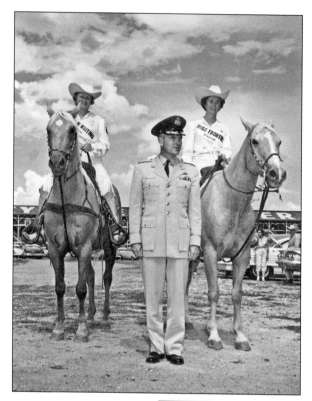

Pictured in 1961 at the rodeo arena are, from left to right, lady-in-waiting April Belecky; Col. Bill Steger, chairman of the Military Committee; and Mary Caldwell, Miss Frontier. The military takes an active role in the pageantry surrounding Miss Frontier by sponsoring the Coronation Ball each year. Continuing the family tradition, Mary Caldwell's daughter Tricia Weppner became Miss Frontier in 1994. (Courtesy of OWM.)

Miss Frontier has the honor of meeting many dignitaries during her reign. Shown in this 1966 photograph, from left to right are Herb Kingman, lady-in-waiting Carolyn Holmes, Miss Frontier Kathleen Keefe, and Wyoming governor Clifford Hansen. (Courtesy of OWM.)

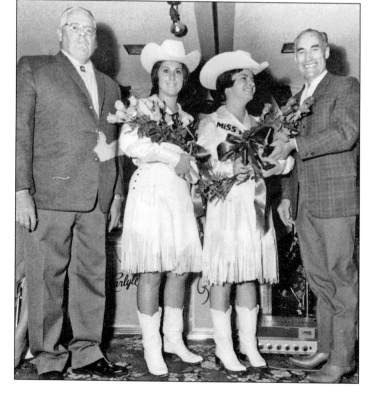

Gus Fleischli, general chairman, joins in at the 1967 Coronation Ball for a dance with Dianne Spear, lady-in-waiting. The lady-in-waiting serves her first year as an understudy and the second year as Miss Frontier. (Courtesy of OWM.)

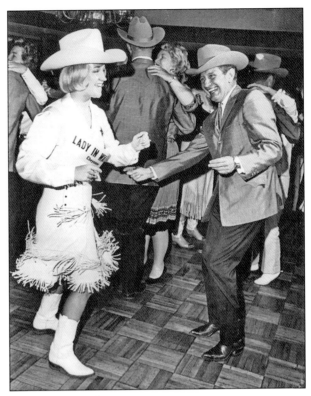

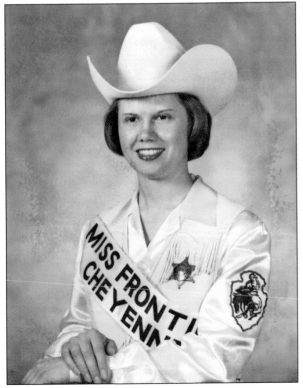

In 1969, Marie Nimmo, niece of the first rodeo queen, Jean Nimmo, repeated the experience, becoming Miss Frontier. Note that the emblem on her left shirtsleeve has changed from its original design of a lone bucking horse. The official logo today features a bucking horse within an arrowhead. (Courtesy of OWM.)

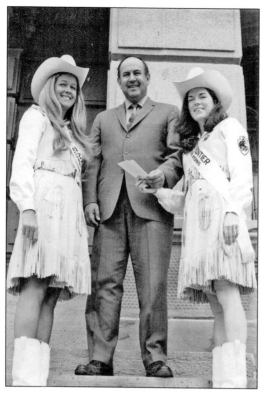

Pictured from left to right are lady-in-waiting Mary Boice and Miss Frontier Julie Robinson, along with Gov. Stan Hathaway, on the steps of the Wyoming capitol in 1972. Mary Boice's grandparents were volunteers; her grandfather Fred Boice was a committeeman in 1921 and 1922, and her grandmother Margaret Boice spearheaded the inclusion of old-time carriages in the parades and was a charter member of the W-Heels in 1926. (Courtesy of OWM.)

One of the responsibilities of royalty is to appear with the rodeo champions of the day. Pictured in 1974, from left to right are Miss Frontier Beth Murray, lady-in-waiting Teresa Jordon, bareback champion Joe Alexander, and committee chairman Duane Von Krosigk. Montie Montana is shown in the background spinning a rope on horseback as part of the entertainment. (Courtesy of OWM.)

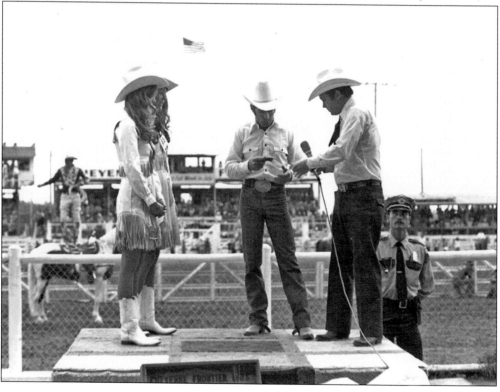

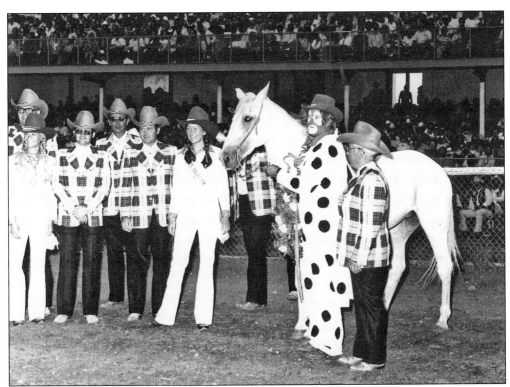

This 1975 photograph, taken in front of the grandstands, features, from left to right, Bill Dubois (publicity), lady-in-waiting Cynthia Lummis, John Rogers (contract acts), Jim Young (grounds), Duane Von Krosigk (tickets), Miss Frontier Teresa Jordan, a white horse, clown Jerry Olsen, and Jack Miller (executive secretary). Each committee is distinguished by wearing matching shirts or jackets. Plaid jackets strike a contrast with the clown's colorful polka dots. (Courtesy of OWM.)

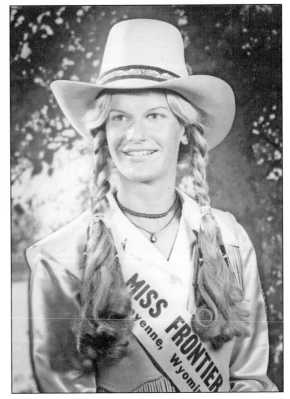

Cynthia Lummis, member of a local ranch family, served as Miss Frontier in 1976. She graduated from the University of Wyoming and became a Wyoming leader. She served in the Wyoming legislature and clerked for the Wyoming Supreme Court, and was Wyoming state treasurer. Lummis is currently the Wyoming representative in the US House of Representatives. (Courtesy of OWM.)

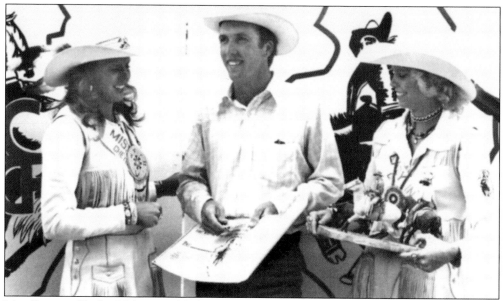

Miss Frontier Shirley Holmes and lady-in-waiting Shelly Howe congratulate Gary Good, Steer Roping champion, following the rodeo in 1979. (Courtesy of OWM.)

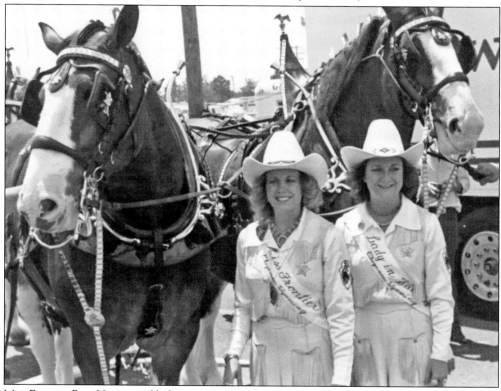

Miss Frontier Rita Homes and lady-in-waiting Tricia Pattno are pictured with the famed Budweiser Clydesdales in 1981. Pattno, who went on to become Miss Frontier in 1982, is the granddaughter of W.A. Norris, a committeeman in 1942. Her uncle, Bill Norris Jr., served on the committee in 1956. (Courtesy of OWM.)

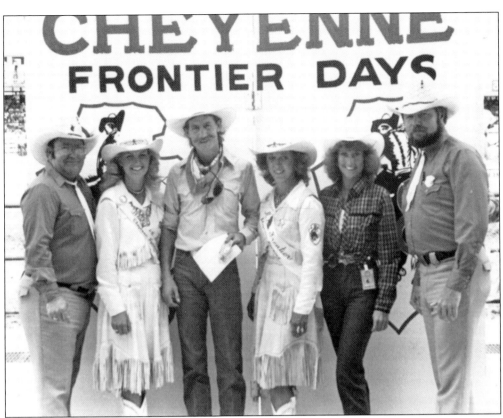

This photograph from the 1983 rodeo features, from left to right, concessions chairman Bill Garner, lady-in-waiting Tamara Dereemer, bull-riding champion Kenny Wilcox, Miss Frontier DeDe Schuppan, unidentified, and executive director Gene Bryan. Bryan served as director from 1979 to 1984, supervising the everyday management and working with each committee chairperson to produce the world's greatest outdoor rodeo. (Courtesy of OWM.)

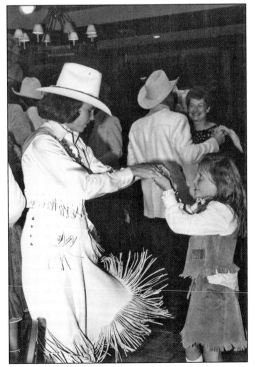

Marcy Morris, Miss Frontier in 1986, again carried on the mother-daughter tradition, as her mother, Norma Jean Bell, had been Miss Frontier in 1949. Marcy is shown dancing with an unidentified girl, exhibiting a tradition of involvement with all ages of spectators. (Courtesy of OWM.)

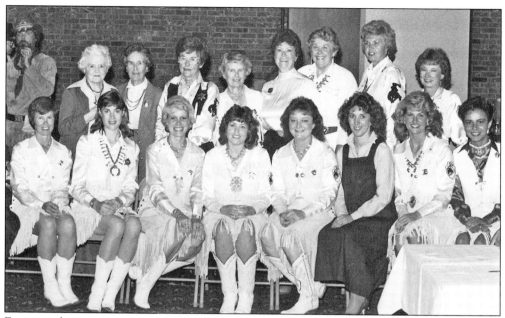

Former rodeo queens reunite in this 1985 photograph. From left to right are (first row) Marie Nimmo Replogle, Beth Murray Edwards, Shelly Howe Erickson, Rita Holmes Helgerson, Tricia Pattno, DeDe Schuppan Wegelin, Tamara Dereemer, and Libby Crews; (second row) Jean Nimmo Dubois, Lois Crain Moor, Louise Holmes Bartlett, Teddy Ann Storey Varineau, Orlene Merritt Mills, Norma Bell Morris, Margy Hirsig, and Mary Caldwell Weppner. (Courtesy of OWM.)

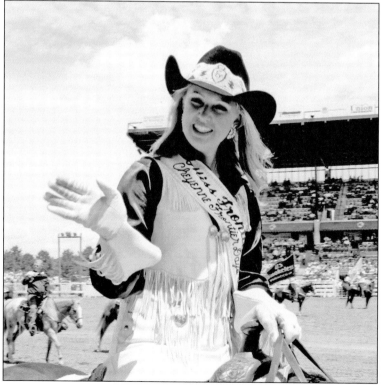

Kimberly Kuhn, Miss Frontier 2009, welcomed visitors during the rodeo grand entry. She graduated from Cheyenne Central High School and the University of Wyoming, and is a member of the Wyoming Rodeo Association, Mile-Hi Barrel Racing Association, and Cowgirls of the West. Kuhn stated she "has been blessed to be raised a Wyoming cowgirl." (Courtesy of Jim Lynch.)

*Six*

# PUTTIN' ON THE RITZ

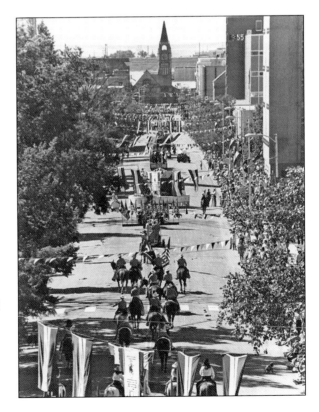

Looking south from the Wyoming Capitol is the historic Union Pacific Railroad Depot. The depot is a National Historic Landmark and considered one of the most beautiful stations in the United States. The frontier parade begins in front of the capitol and winds its way south on Capitol Avenue toward the depot and through downtown Cheyenne. (Courtesy of OWM.)

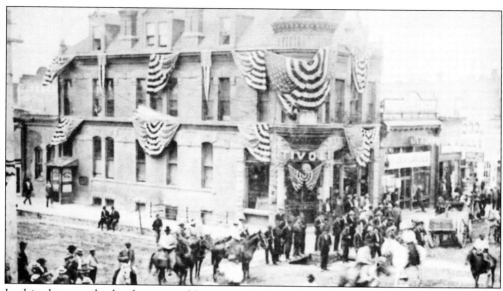

In this photograph, the three-story Victorian style Tivoli Building at the corner of Seventeenth and Carey Avenue is all decked out for the festival. Historical accounts say the committee planning the first frontier event met in one of the upstairs rooms. In 1978, the Tivoli, built in 1892, was added to the National Register of Historic Places. It is currently owned by Gov. Matt Mead. (Courtesy of OWM.)

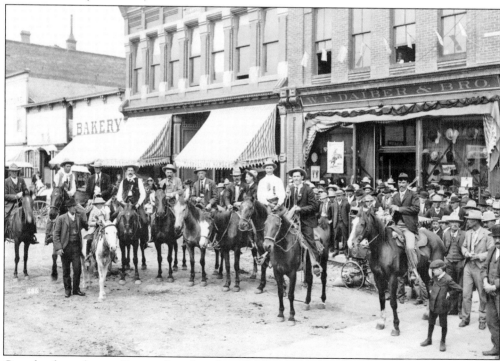

Crowds of people standing on the sidewalk and folks on horseback appear to be waiting for the frontier parade to begin in this photograph from the first decade of the 20th century. Note the flags in the second-story windows of the haberdashery. (From the J.E. Stimson Collection, Wyoming State Archives, Department of State Parks and Cultural Resources.)

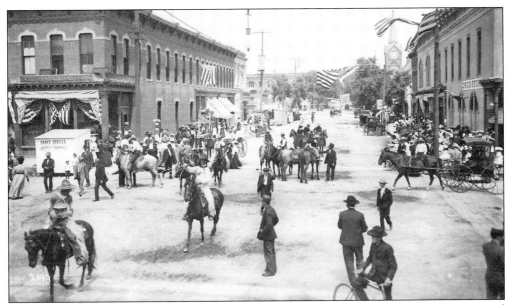

People on horseback, riding in carriages, and walking gather for the parade near Citizens National Bank in downtown Cheyenne in 1908. Vendors lined the streets selling their goods; note the vendor on the corner offering "fancy shells." The wind was blowing the day of this parade, as evidenced by the flapping bunting. (Courtesy of OWM.)

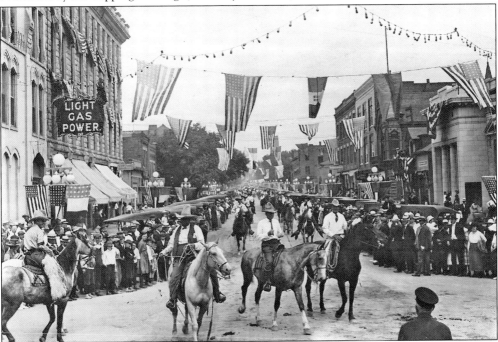

Early event organizer and cowboy C.B. Irwin is pictured second from left on horseback, leading the parade with other unidentified riders. Irwin cut quite a figure at the rodeo and was the World Champion Steer Roper in 1906. Throughout his lifetime, he ran a Wild West show, was a rancher, and is said to have owned the most "buckingest horse of 'em all," the famous Steamboat. (Courtesy of OWM.)

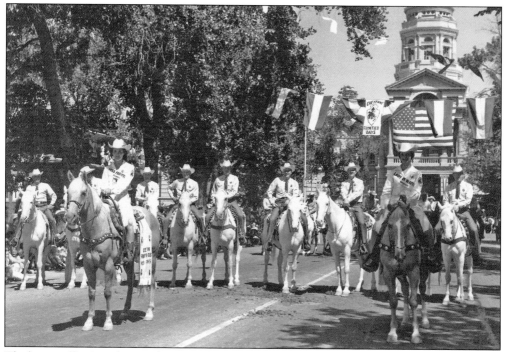

The honor of leading the parade eventually was bestowed to Miss Frontier, the lady-in-waiting, and members of the general committees. Miss Frontier Susan Dubois and lady-in-waiting Sharon Kay Hanson, along with committee chairmen, led this 1964 parade. The 10-day celebration features four large parades, each one brimming over with floats, horses, marching bands, carriages, and folks of all ages. (Photograph by Bill Miranda; courtesy of OWM.)

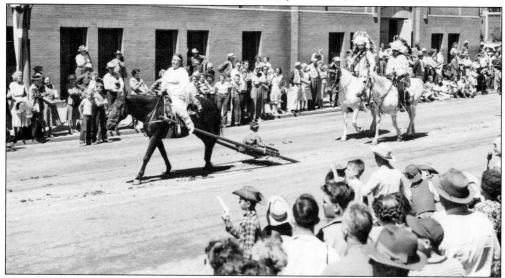

Native Americans have participated in the Cheyenne event beginning with the second celebration in 1898. Pictured around 1950, this group in traditional clothing parades by the Masonic hall. The woman riding the horse in front is pulling a travois with a child aboard, demonstrating a customary mode of transportation or way of moving goods. (Wyoming State Archives, Department of State Parks and Cultural Resources.)

84

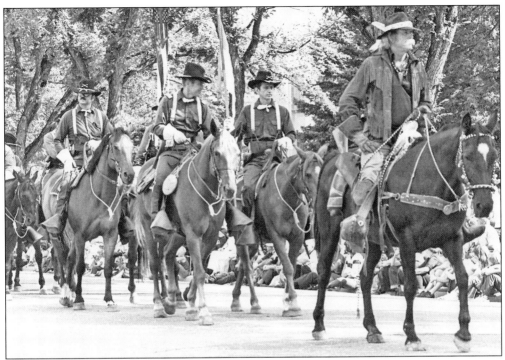

The mounted cavalry from Fort D.A. Russell played a significant role in the protection and settling of Cheyenne. These riders from the 5th Cavalry reorganized unit, in historical dress, represent that bygone era as they ride in the parade, around 1976, led by a frontier scout. (Photograph by Randy Wagner; courtesy of OWM.)

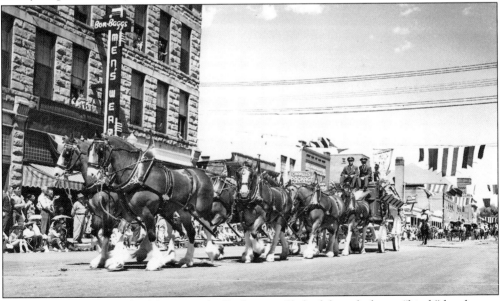

Pulling a red, white, and gold wagon, the Budweiser Clydesdale eight-horse "hitch" has been a parade fixture since the 1950s. Anheuser-Busch owns more than 200 Clydesdales, kept at various locations throughout the United States. The Clydesdales head for Frontier Park following the parade, where folks may visit them and learn about their history. (Courtesy of OWM.)

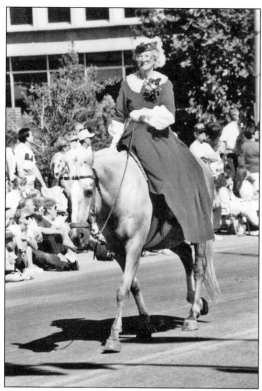

Originally from Scotland, Dorothy Richardson came to Cheyenne in 1947. Known as "The Lady in Red," she rode sidesaddle in the parades beginning in 1948. Her dress is a copy of one worn by the daughter of a commanding officer at Fort D.A. Russell. Her saddle was made by well-known saddlemaker Frank Meanea in the late 1800s. Dorothy still rides in parades, though usually on one of the historic wagons. (Courtesy of Jim Lynch.)

These working ranch horses are shown pulling a wagon filled with cowpokes and horseback riders. Locals and visitors arrive early in the morning to vie for the perfect viewing location. (Photograph by Randy Wagner; courtesy of OWM.)

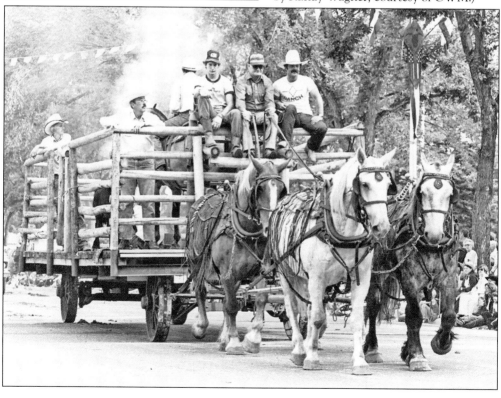

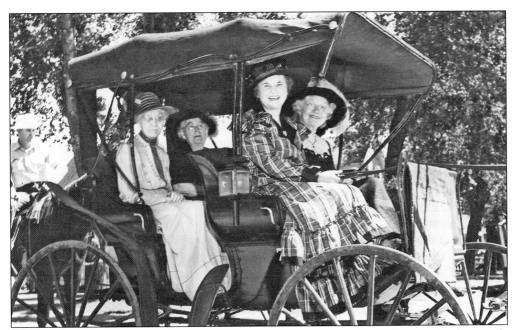

Four women dressed in period costumes occupy this vintage carriage. Carriages in the parade are generally from the collection of the Cheyenne Frontier Days™ Old West Museum, each one carefully restored. Margaret Boice, beginning in 1927, was influential in organizing the vehicle section of the parade. She and others also recruited and helped to outfit the participants in appropriate costumes. (Photograph by Hugh Bates; courtesy of OWM.)

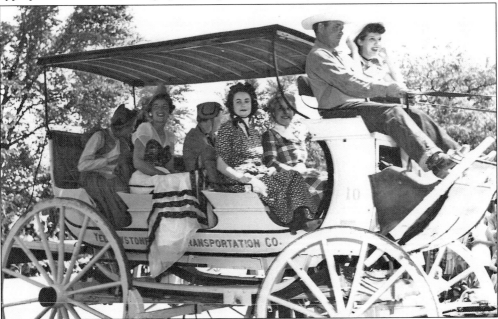

Bright yellow and completely restored to perfection, this Yellowstone Park Transportation Company coach was originally used to transport visitors through the nation's first national park. The coach usually appears in each frontier parade filled with modern-day passengers wearing period costumes. (Courtesy of OWM.)

Pictured here in 1958, rodeo clown and bullfighter Benny Bender was a parade favorite. One little fellow was lucky enough to take a ride with Bender, who handled the Cheyenne rodeo clowning chores from 1947 to 1959. Bender is reported to have "brought down the house" at the 1949 rodeo when he parachuted from a helicopter into the arena, a feat that was touted as the world's shortest parachute jump. (Courtesy of OWM.)

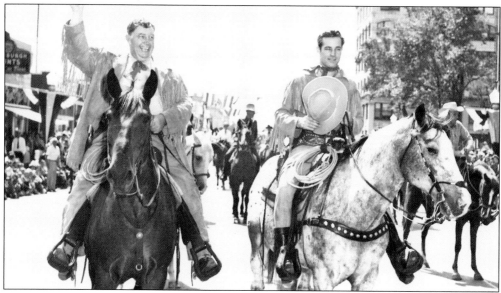

Many celebrities came to participate in the Cheyenne celebration, including the parade. Andy Devine (left) and Guy Madison tip their hats to the spectators in this photograph from around the 1950s. Both men were film and television actors, best known for their roles in the Western television series *The Adventures of Wild Bill Hickok*. (Courtesy of OWM.)

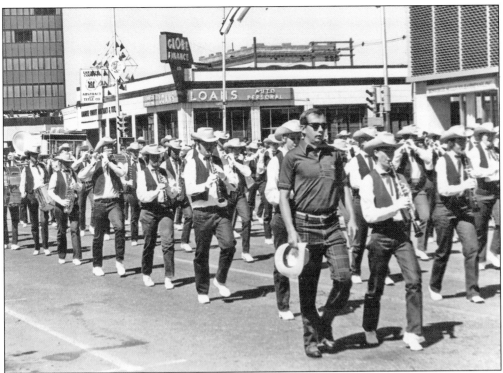

Marching bands are a crowd favorite along the parade route. The bands of the Laramie High School Plainsmen (above) and the Thermopolis High School Wildcats (below) marched in this parade from around the 1950s. Bands are strategically placed throughout the parade route so as not to interfere with each other or the parade animals. (Courtesy of OWM.)

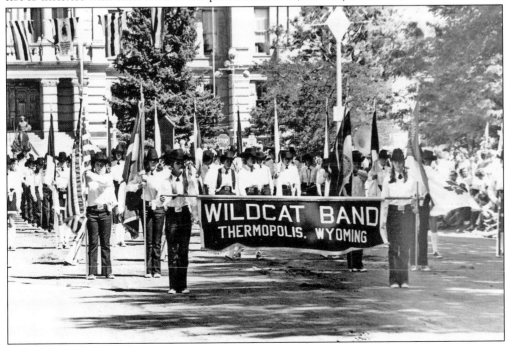

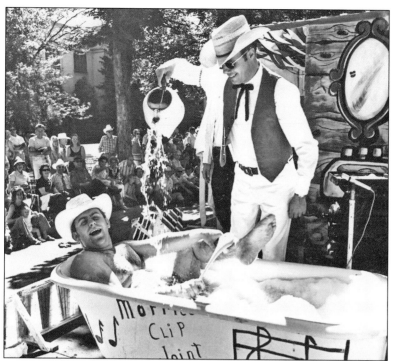

The Old Tonsorial Parlor float shows good sportsmanship from the cowboy in the bathtub, who is frequently doused with water as the parade winds its way through Cheyenne streets. The float, shown in both photographs, represents a cowboy's Saturday night when he would undergo his weekly bath and a haircut. (Courtesy of OWM.)

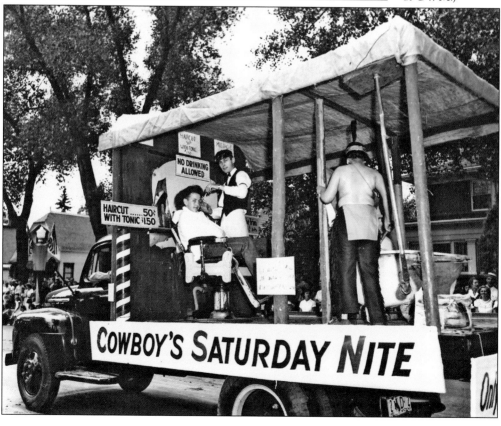

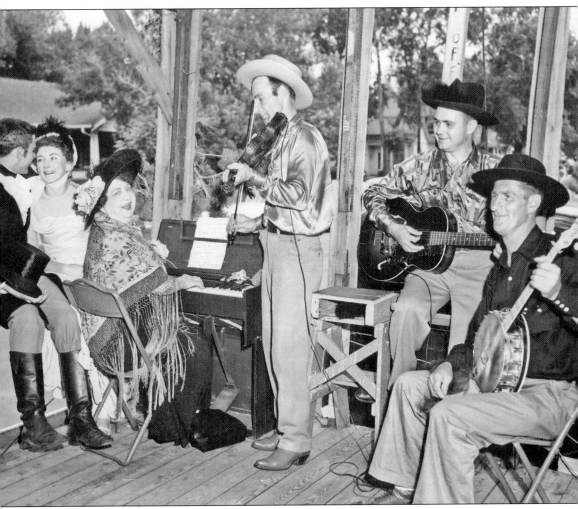

Dazee McCabe Bristol, seated at the piano, graduated from Cheyenne High School in 1897, taught elementary school, and married Charles Bristol. She became a cherished resident and local actress who obtained fame in 1926 when she was featured in a full-page photograph in *Redbook* magazine. In 1926, she was invited to create floats for the frontier parade, a tradition that lasted many years. After becoming a widow at the age of 50, Bristol became a writer for the *Wyoming Tribune* and the *Wyoming Stockman Farmer* and was a charter member of Wyoming Press Women. She continued as a parade organizer and participant, and was active in many Cheyenne civic organizations. On her 100th birthday in 1978, Gov. Ed Herschler formally declared the day Dazee Bristol Day, and the Wyoming Press Women honored her for being the oldest working press woman in the nation. A member of the Cheyenne Frontier Days™ Hall of Fame, Bristol is credited with being a fierce advocate of the event. (Union Pacific Railroad Photograph, Wyoming State Archives, Department of State Parks and Cultural Resources.)

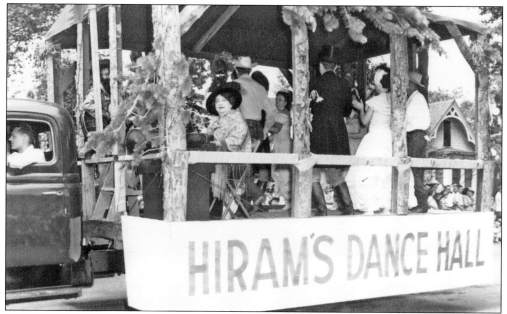

Dazee Bristol said she was asked to create floats depicting the history of early Cheyenne. One of her floats, Hiram's Dance Hall, featured square dancers and musicians. Local fiddler Hiram Davidson played tunes while Dazee accompanied him on the organ and couples danced. It was reported that Dazee was resplendent in a sparkling gown and a large hat covered with ostrich plumes. (Courtesy of Wyoming State Archives, Department of State Parks and Cultural Resources.)

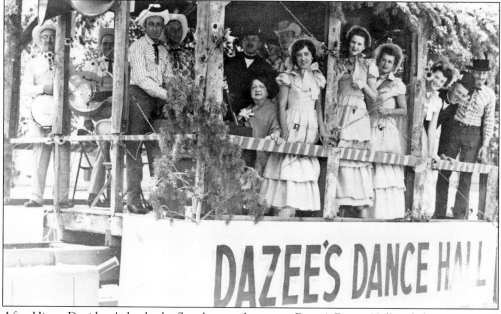

After Hiram Davidson's death, the float became known as Dazee's Dance Hall and always appeared with Dazee Bristol at the keyboard. Dazee's dancers were often descendants of early pioneers and wore the same style dresses in different colors. The men on the float dressed as old-time cowboys or gamblers. Bristol played the pump organ on the Dance Hall float for more than 50 years. (Courtesy of the Wyoming State Archives, Department of State Parks and Cultural Resources.)

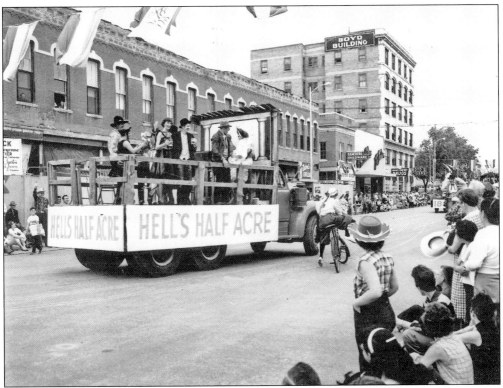

Dazee Bristol's "Hell's Half Acre" float traditionally brings up the rear of the parade. With a mix of cowboys, saloon girls, Native Americans, and maybe even a scoundrel or two, it is said that "gaiety and hilarity reigned." Today's parade viewers can still see replications of Bristol's floats like Hell's Half Acre, Dazee's Dance Hall, and the Silver Crown Mine. Bristol died in 1983 at the age of 105. (Courtesy of the Wyoming State Archives, Department of State Parks and Cultural Resources.)

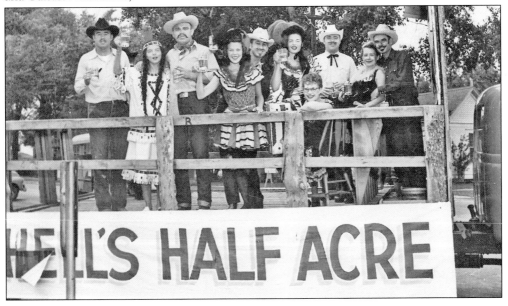

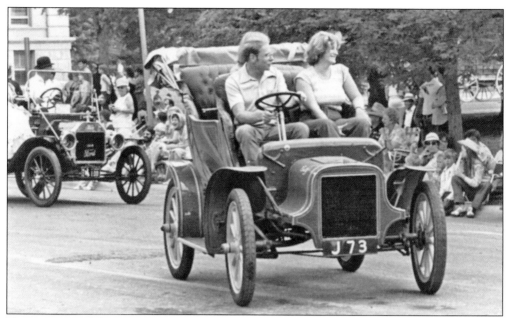

Vintage automobiles are provided with a special section in each parade. Most of them are owned by individuals who have restored them with care. (Courtesy of OWM.)

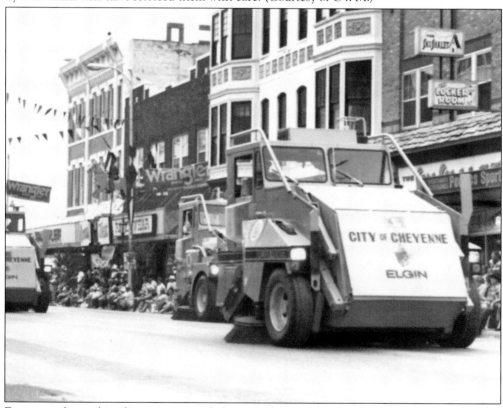

Every parade needs a cleanup crew, and the city of Cheyenne provides just that as the parade comes to an end. (Courtesy of OWM.)

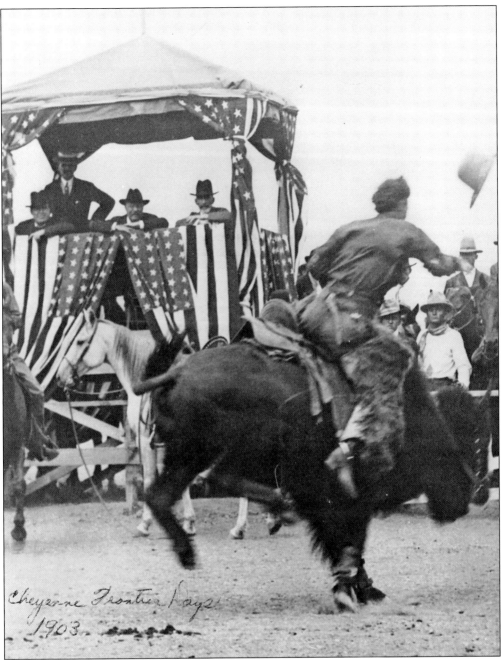

Cheyenne Frontier Days
1903

Pres. Theodore Roosevelt was a distinguished visitor to Cheyenne on May 29, 1903. He specifically requested to see some cowboys in action, and the Frontier Day committee staged an event just for him. From the viewing stand, Roosevelt, third from left with unidentified companions, watches a cowboy attempting to ride a buffalo. After his presidency, Roosevelt visited Wyoming's capital city again in 1910. A parade was held in his honor featuring Buffalo Soldiers of the 9th and 10th US Cavalry from Fort D.A. Russell, the 11th Infantry, and the 4th Field Artillery. Roosevelt's attendance at Cheyenne Frontier Days™ is credited with bringing the event national recognition and added prestige. (Courtesy of OWM.)

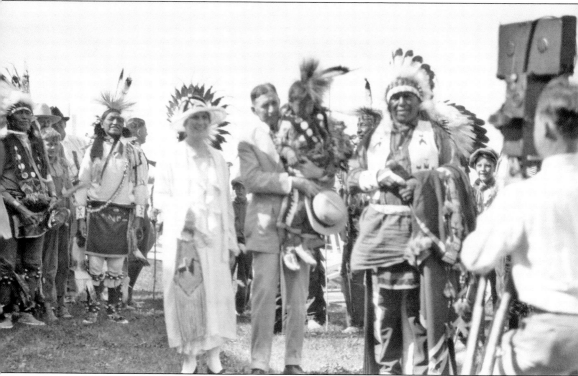

Wyoming governor Nellie Tayloe Ross, the nation's first female governor, welcomed Vice Pres. Charles Dawes to the celebration in 1925. Dawes, shown in the center of the photograph holding a Native American child, greeted a large crowd of visitors to the event. As a guest of honor, the vice president was adopted by members of the Oglala Sioux Tribe, who named him "White Father Number Two." Chief Jumping Eagle, shown on the right, presented him with a pipe made of stone and a beaded tobacco pouch. Governor Ross, shown to the left of Dawes, was accepted into the tribe as a princess and was presented with a beaded buckskin bag. Others shown in the photograph are unidentified. (Courtesy of the Wyoming State Archives, Department of State Parks and Cultural Resources.)

Hollywood actor John Wayne, right, is pictured here with rodeo cowboy Turk Greenough. When he was not attending a rodeo, Greenough could be found in Hollywood working as a stuntman in John Wayne's movies. He also appeared in the movie *Gone with the Wind*. (Courtesy of OWM.)

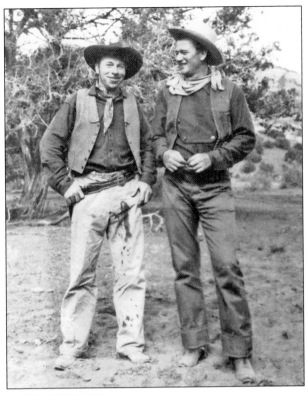

Montie Montana is pictured here with his wife, Louise, and Montie Jr. They were a family of rodeo entertainers, skilled in all forms of Western arena art, such as trick riding and roping. A familiar figure at Cheyenne Frontier Days,™ Montie was inducted into the Cowboy Hall of Fame in 1989. (Courtesy of OWM.)

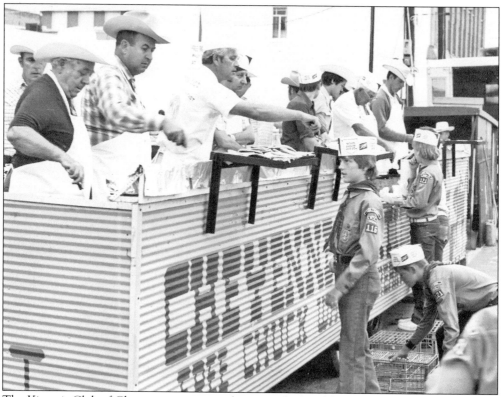

The Kiwanis Club of Cheyenne sponsors a free pancake breakfast on three different mornings during the frontier celebration. The Kiwanis took over the event from the 4-H in 1968. Gov. Stan Hathaway (second from left, in the plaid shirt) is shown demonstrating his cooking skills in this 1974 photograph. Boy Scouts stand ready to assist and help serve breakfast. (Courtesy of the Wyoming Travel Commission; from OWM.)

It takes skill to flip a pancake into the air and skill to catch it. About 300 volunteers show up at the crack of dawn to prepare for the thousands of people who stand in line for free pancakes. The pancake breakfast serves two purposes: to feed and entertain people, and as a civil-defense exercise. (Courtesy of OWM.)

Entertainment abounds during the free pancake breakfasts. The Smith twins, Amy and Annie, shown at right, were a mainstay for many years. The Air Force Thunderbirds precision flying team, Native American dancers, and other dignitaries are also usually in attendance. When the breakfast was organized more than 50 years ago, 2,650 people were served. A record was established in 1996 when 40,000 people attended the breakfast. Today, it is estimated that up to 16,000 people can be served at one pancake breakfast. People stand in lines that wind around the downtown buildings and are served within 20 minutes. As shown below, after receiving their pancakes, ham, coffee, and milk, attendees are seated on hay bales to partake of the meal and the entertainment. (Courtesy of OWM.)

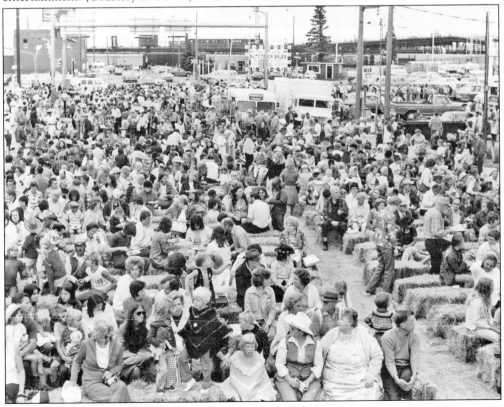

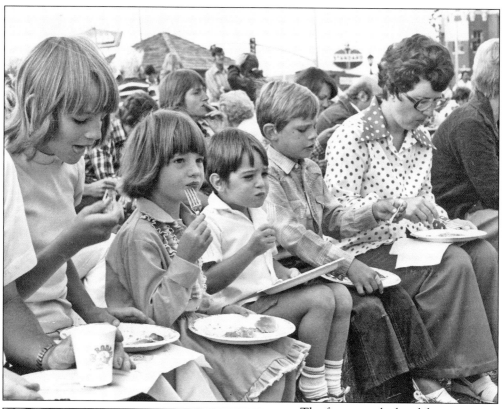

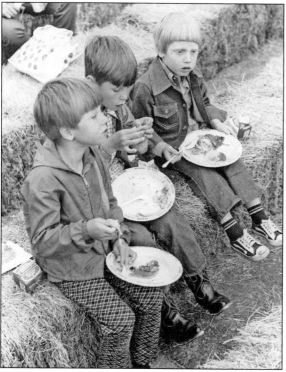

The free pancake breakfasts attract all ages, including locals and visitors alike. Families can be seen filling up on pancakes covered with butter and syrup, ham, and milk or coffee. In 1971, the Kiwanis served 5,000 folks at one breakfast, ladling out 16,000 pancakes, 770 pounds of ham, and 178 gallons of coffee. In 2012, the volunteers used a total of 520 gallons of coffee, 9,200 cartons of milk, 630 pounds of butter, 475 gallons of syrup, and 3,500 pounds of ham to feed visitors from all 50 states and several foreign countries. (Courtesy of OWM.)

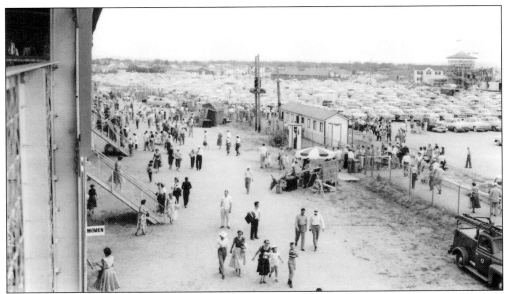

After the downtown Cheyenne parades and the pancake breakfasts, crowds begin to migrate to Frontier Park in north Cheyenne. The photograph above shows the parking lot filled with automobiles that brought people to the grounds. Folks come for the rodeo, carnival, exhibition halls, dancing, food, and entertainment. The photograph below shows the carnival with its rides, games, and food booths. (Photographs by Francis Brammer; courtesy of the Wyoming State Archives, Department of State Parks and Cultural Resources.)

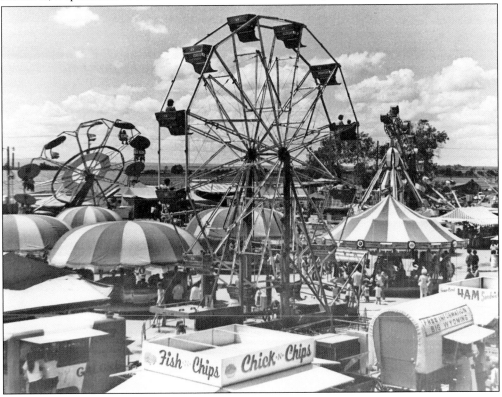

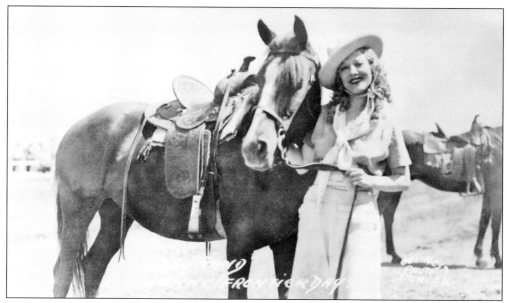

Beginning in 1929, entertainers were featured at night shows. Sally Rand, a vaudeville performer pictured here in 1935, wore a white buckskin divided skirt, vest, and satin shirt. Rand is credited with suggesting that Miss Frontier be outfitted in the same fashion; thus a similar costume was adopted in 1936 as the official royalty outfit and continues today with slight modifications. (Wyoming State Archives, Department of State Parks and Cultural Resources.)

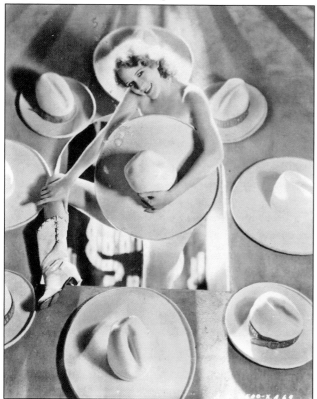

Sally Rand was controversial when she performed her famous fan dance in Cheyenne, but she made friends and often posed for photographs. The owner of Max Meyer's clothing store on Carey Avenue arranged for this photograph of the famous dancer among his selection of Stetson hats. Rand fell in love with the West and cowboys, marrying the champion bronc rider Turk Greenough in 1942. (Wyoming State Archives, Department of State Parks and Cultural Resources.)

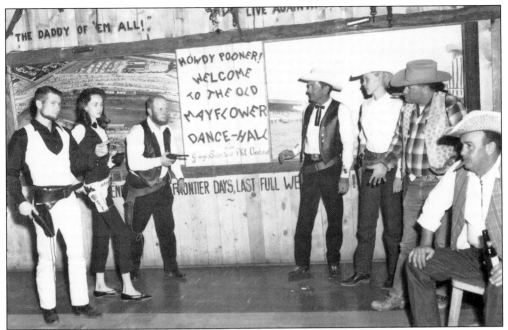

Downtown Cheyenne was often the scene of reenactments and portrayals of the Old West during the frontier celebration. The Mayflower Restaurant and Dance Hall was a famous hangout for locals and visitors. The scene in this photograph may have been at the Mayflower, or staged as a performance during the old-fashioned melodrama. (Photograph by Francis Brammer; courtesy of the Wyoming State Archives, Department of State Parks and Cultural Resources.)

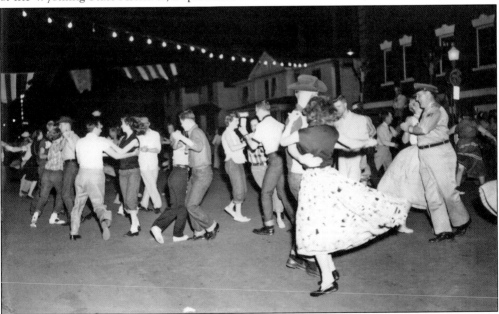

Street dances were a popular activity in downtown Cheyenne during Frontier Days. The style of dress in this photograph indicates it was taken in the 1950s. Note the serviceman on the right. (Photograph by Francis Brammer; courtesy of the Wyoming State Archives, Department of State Parks and Cultural Resources.)

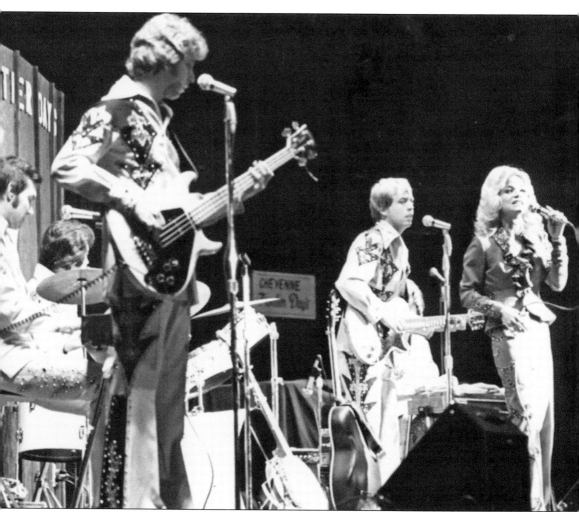

Nightly entertainment is featured at Frontier Park during the annual event. Beginning in the late 1970s, performers like Barbara Mandrell, shown with her band, opened the show. Other all-time favorites have included Johnny Cash, Willie Nelson, Garth Brooks, Charlie Daniels, George Strait, and Reba McEntire. In recent years, performances have included rock and roll bands and alternative entertainment. (Photograph by Randy Wagner; courtesy of OWM.)

# Seven

# NATIVE AMERICANS

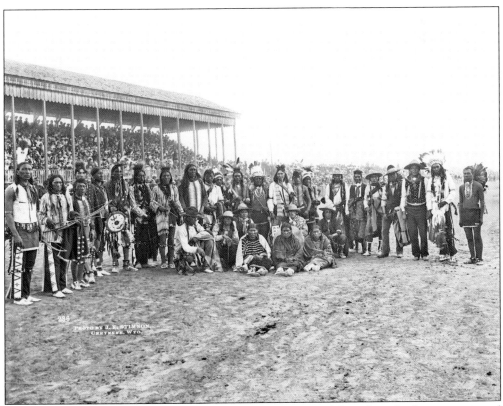

Beginning in 1898, members of the Oglala Sioux, Shoshone, and Arapaho tribes have participated in the Cheyenne celebration by sharing their native dances and traditional dress. Their village at Frontier Park gives them an opportunity to tell stories, dance, and sell their goods. This group is shown in front of the grandstands in 1902. (From the J.E. Stimson Collection, Wyoming State Archives, Department of State Parks and Cultural Resources.)

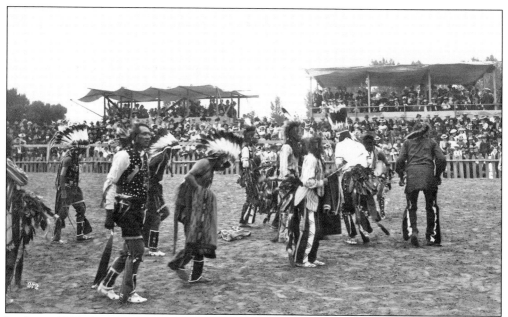

In this c. 1902 photograph, Native Americans perform a traditional dance before the crowd at Pioneer Park. (From the J.E. Stimson Collection, Wyoming State Archives, Department of State Parks and Cultural Resources.)

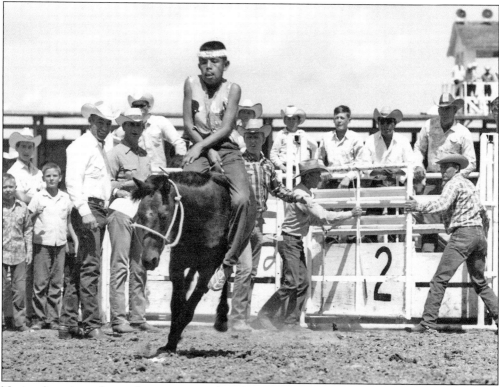

Native Americans have often participated in the sport of rodeo. This young rider displayed his bareback riding skills at the Cheyenne rodeo. (Courtesy of OWM.)

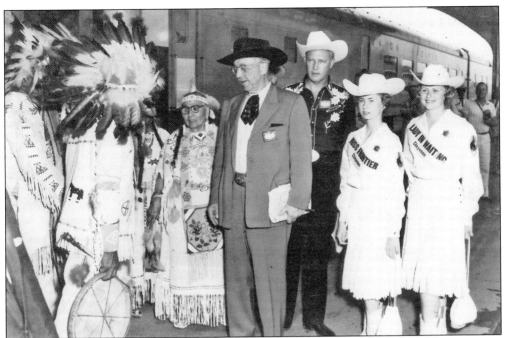

In 1961, the reigning Miss Frontier, Mary Caldwell (second from right) lady-in-waiting April Belecky (right), committeeman Ralph Ausman (in white hat), and *Denver Post* publisher Palmer Hoyt (in black hat) greeted Princess Blue Water and unidentified members of the Oglala Sioux tribe. Hoyt was instrumental in continuing the long-held tradition of the newspaper's association with Cheyenne Frontier Days.™ (Courtesy of the American Heritage Center, University of Wyoming.)

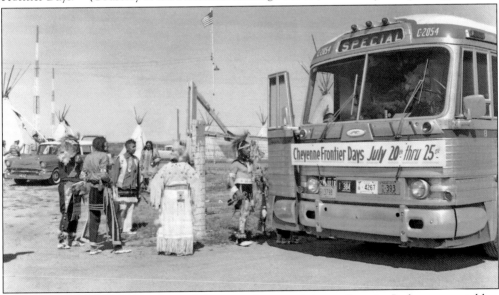

Native Americans clad in traditional dress are shown arriving at Frontier Park on a special bus in 1959. Throughout each celebration, members of various tribes demonstrate crafts, perform traditional dances, sell their handmade goods, and share their lifestyle with visitors. (Photograph by Francis Brammer, courtesy of the Wyoming State Archives, Department of State Parks and Cultural Resources.)

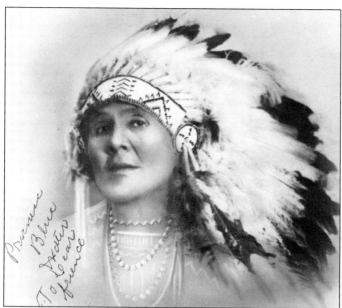

In the 1930s, the Indian Committee realized the value of communicating with a tribal spokesperson. Princess Blue Water of the Oglala Sioux stepped up and accepted a position of leadership. That was the beginning of a long-standing association between the tribe and the organization. Born Rose Powell Nelson in 1880, she traveled with the Buffalo Bill Show as a child. Buffalo Bill called her Princess Blue Water. (Courtesy of OWM.)

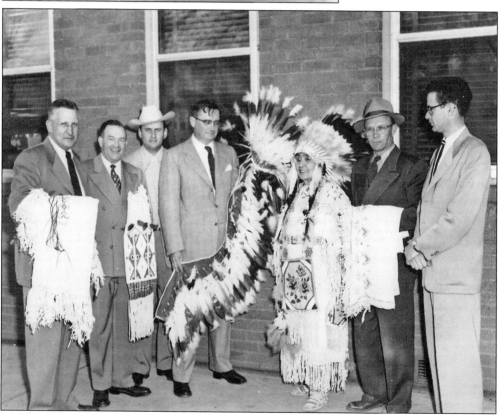

In the 1950s, Princess Blue Water presented members of the Indian Committee with traditional handcrafted garments. Pictured from left to right are Robert Walton, Hugh Lenhart, Don Dugan, Willits Brewster (committee chairman), Princess Blue Water, Harold Hanes, and Norm Udevitz. (Courtesy of OWM.)

Princess Blue Water was often publicly recognized for her contributions to Cheyenne Frontier Days.™ She received her education at the Franklin Institute in Philadelphia and frequently served as an interpreter. Nicknamed "Rosie" by some, she was usually seen carrying a bag, as shown in this photograph, featuring an intricate traditional beaded rose pattern. Others in this photograph are unidentified. (Courtesy of OWM.)

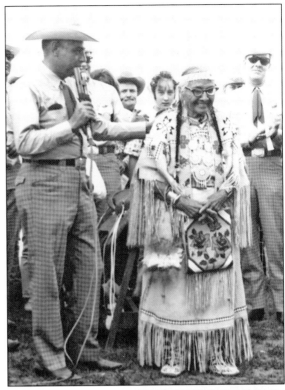

Princess Blue Water appeared at Frontier Park in this c. 1948 photograph with Indian Committee chairman Robert Walton (left), Bill Elliott, and Low Cloud, a four-year-old Sioux child. The princess participated for more than 60 years and was a revered tribal matriarch. In the 1960s, she relegated her authority to Chief Iron Shell, who, along with others, continued the tradition of bringing members of the Sioux Nation to the event. (Courtesy of OWM.)

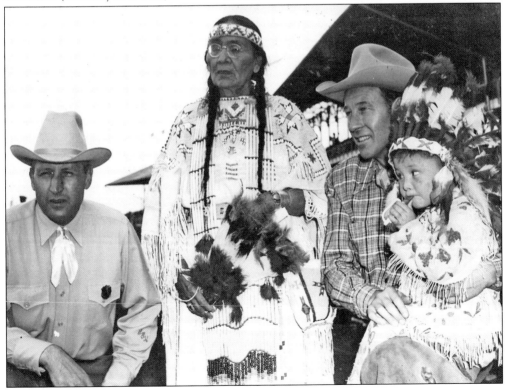

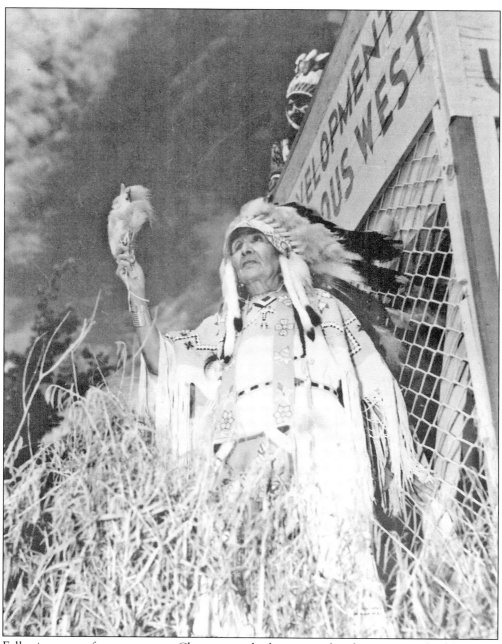

Following years of appearances at Cheyenne and other national and international celebrations, Princess Blue Water retired. She had performed with Buffalo Bill's Wild West Show, guided countless Native American children through stages of life, and was an inspiration to many. She died on June 11, 1972, at the age of 92. (Courtesy of OWM.)

# *Eight*

# THOSE AMAZING VOLUNTEERS

Since its beginnings, the Cheyenne celebration has been successful due to the efforts of volunteers. Committees work long hours in preparation and throughout the event. They usually kick off the festivities by appearing in each parade. Shown from left to right in front of the capitol in 1948 with a tip of their hats are Jim Powers, general chairman Ace Tyrrell, Bob Walton, Jack Ryan, Robert Hanesworth, Col. John Elliott, and Dr. W.B. Harris. (Courtesy of OWM.)

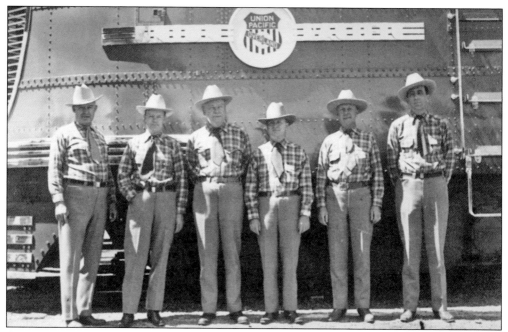

Committee members are distinguished by their matching outfits. Pictured in 1936 from left to right are C.A. Black (general chairman), Robert Hanesworth (secretary), J.H. Schroeder (treasurer), D.T. Morris (tickets), Fred Porter Sr. (Indian), and W.J. Dinneen Sr. (parade). The Union Pacific Railroad was a strong supporter of the celebration, often carrying committees on booster trips and bringing guests to the celebration. (Courtesy of OWM.)

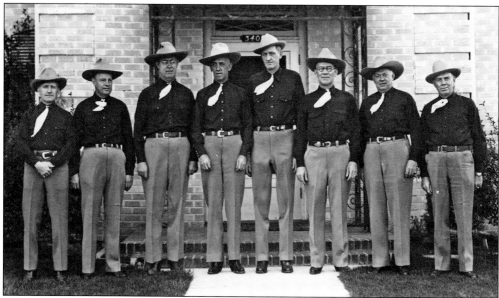

The 1944 committee included, from left to right, J.A. Storey, Robert Hanesworth, general chairman Rudy Hofmann, Col. G. McGary, F.B. McVicar, W.A. Norris, Col. E.J. Zimmerman, and Charles Hughes. Hofmann served nine years as general chairman and is credited with helping the celebration continue during World War II and making the rodeo profitable. His daughter Lois Hofmann was Miss Frontier in 1946. (Courtesy of OWM.)

Chairman John Bell, left, is shown horsing around in the arena with rodeo judges, from left to right, Clayton Danks, George Hyatt, and George Marty. Bell was in charge of the rodeo arena in 1922. Most volunteers in the early days had ties to the area either through owning a business, ranching, or family. Throughout the year, volunteers perform various functions, including ground and building maintenance. (Courtesy of OWM.)

The Merritt name is synonymous with Cheyenne Frontier Days™ and an example of the volunteer traditions displayed by local families. King Merritt, shown on the right, came to Wyoming in 1912. He worked for area ranches, rodeoed, and established his own ranch. Several generations of Merritts have been participants, volunteers, and supporters of the Cheyenne rodeo. Also pictured are King's son Hyde (left) and grandson Chip, perched on a saddle. (Courtesy of OWM.)

Frontier representatives took the train to Denver in 1975 for promotional purposes. Pictured here from left to right are (first row) John Rogers and Jack Miller; (second row) Col. W.W. Wildman, Bud Racicky, lady-in-waiting Cynthia Lummis, Gov. Ed Herschler, Bill Dubois, Duane Von Krosigk, Miss Frontier Teresa Jordan, and Marvin Helart. Lummis and Jordan were both recognized as superior horsewomen and accomplished public speakers. (Courtesy of OWM.)

United Airlines was a supporter of the event and helped to sponsor promotional trips. Committee members and flight attendants are shown in this 1967 booster trip to Chicago. From left to right are unidentified, general chairman Gus Fleischli, Marvin Leff, unidentified, Virgil Slough, James Storey, Dick Pickett, and Lloyd Flynn. (Courtesy of OWM.)

The Heels group consists of past committeemen and volunteers who lend their expertise and oversight to activities associated with the event. Shown standing in the rodeo announcers and timers booth from left to right in this 1937 photograph are announcer Ed Storey, Morton Nisbet, William Devere, F.B. McVicar, George Storey, Francis Fitch, I.R. Townsend, and Charles Hirsig. Ed Storey filled the announcer's position from 1925 to 1949 and founded the Heels. (Courtesy of OWM.)

The "W-Heels" group consists of women responsible for horse-drawn carriages and vintage garments. Shown in 1979, from left to right, are (first row) Shirley Flynn, Minnie Holbrook, Beverly Vandehei, Elinore Robinson, Enid Lummis, Ann King, Louise Cole, Jackie Boice, and Katherine Halverson; (second row) Tuda Crews, Carrell Cooke, Mary Helen Ausman, Mary Weppner, Ann Smith, Norma Morris, Marietta Dinneen, Jean Nivotny, Ann Palen, Evelyn Patterson, Mary Liz Carpender, and Chris Francis. (Courtesy of OWM.)

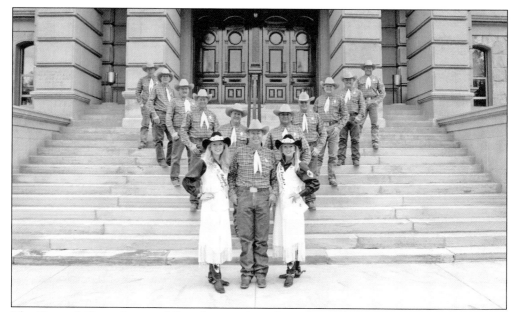

The General Committee and Royalty posed on the steps of the Wyoming Capitol in 2009. Pictured from left to right are Doug Elgin (security), Jack Smith (Indian), Jim Gorman (tickets), Eric Nordburg (parade), Bill Cole (contestants), Rachel Shutter (lady-in-waiting), Charley West (general chairman), Kim Kuhn (Miss Frontier), Joe Lopez (contract acts), Gunner Anderson (grounds), Gary Pond (military), Jerry Ciz (public relations), and Matt Jones (concessions). (Courtesy of Jim Lynch.)

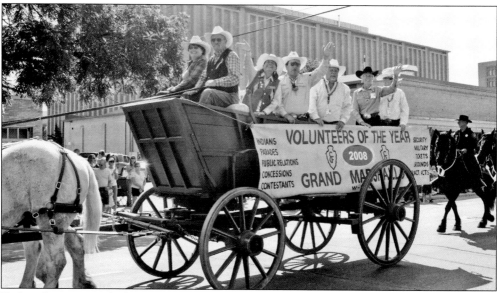

Today, the success of Cheyenne Frontier Days™ is made possible with the assistance of more than 2,500 volunteers, along with a small staff of paid employees. Each year, one person who exemplifies the spirit of the celebration is selected from each of the 10 committees and honored as a Volunteer of the Year. The 2008 award winners shown here in the back of a wagon are, from left to right, Mary Randolph (Indian), Cheyenne Leal (contestants), Jim Messer (public relations), Ramona McCoy (parades), and Brad Westby (concessions). (Courtesy of Jim Lynch.)

# *Nine*

# LEAVING A LEGACY

A monumental statue honoring Lane Frost, a bull rider who perished while riding in Cheyenne, stands at Frontier Park. The statue, representing a tribute to all rodeo athletes who have died during competition, was created by Chris Navarro, himself a former bull rider. The artist captured a sense of movement and precision that only a rider and the bull can know. (Photograph by Randy Wagner; courtesy of OWM.)

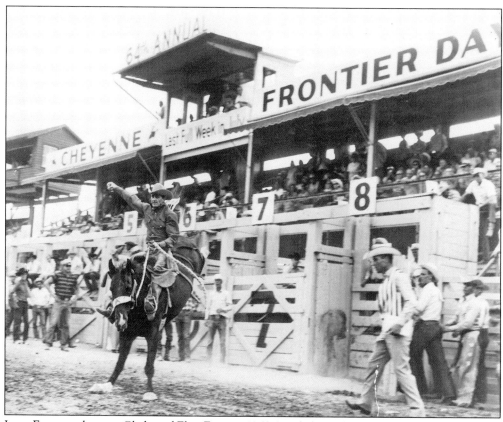

Lane Frost was born to Clyde and Elsie Frost in 1963. His father, Clyde, followed the rodeo circuit as a saddle bronc and bareback rider. Clyde is shown here performing at Cheyenne Frontier Days™ in 1957. (Courtesy of OWM.)

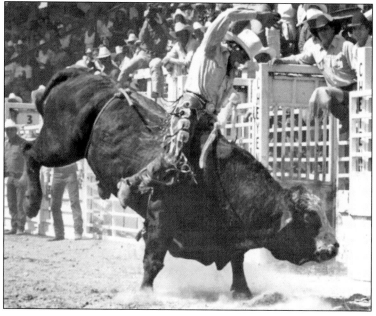

On July 30, 1989, Lane Frost completed an 87-point ride on a Brahma bull. Upon landing, with his back to the bull, he did not realize the bull was charging. Frost was gored by the bull, and died in the arena. His contributions to bull riding have been honored in many ways. Singers have paid tribute to him, and the movie 8 Seconds tells his life story. (Courtesy of OWM.)

Lane Frost, right, assisted an unidentified youngster in the "Exceptional Rodeo." These special events are staged at many rodeos throughout the country. Sponsored in Cheyenne by the Buckle Club, the event pairs challenged children with rodeo contestants who teach and encourage them in contests like barrel racing, steer roping, and relay races. Each child receives special attention and mementos of the day. (Courtesy of Sue Rosoff; from OWM.)

In 1989, prior to his fateful ride, Lane Frost (center) and fellow bull rider Tuff Hedeman (right) were interviewed by George Michael (left). Frost was named to the ProRodeo Hall of Fame, Professional Bull Riders Ring of Honor, Frontier Days Hall of Fame, Texas Cowboy Hall of Fame, and Oklahoma Sports Museum. Hedeman won the 1988 Cheyenne All-Around and 1995 Bull Riding. (Courtesy of Sue Rosoff; from OWM.)

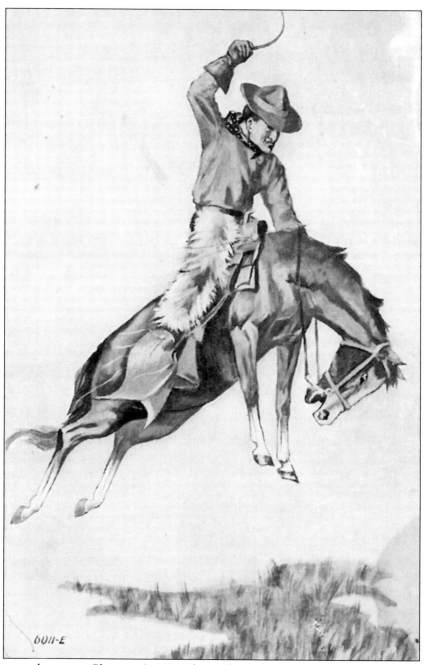

This image advertising Cheyenne's event shows the spirit that embodies the sport of rodeo. Cowpokes, like many other athletes, take risks every time they enter a competition. The authors pay tribute to those folks who died while participating at the Cheyenne rodeo: Floyd Irwin (stock wrangler) July 20, 1917; Eddie Burgess (steer roper) July 25, 1923; Reva Grey (relay racer) July 30, 1938; Nancy LaPoint (cowpony racer) July 26, 1939; Rod Bullock (chuckwagon driver) July 17, 1960; Joseph Creel (chariot racer) July 28, 1969; Gordie Bridge (chuckwagon outrider) August 2, 1971; Capt. Charles Carter (Air Force Thunderbirds pilot) July 25, 1977; Randy Evans (chuckwagon outrider) 1986; and Lane Frost (bull rider) July 30, 1989. (Courtesy of OWM.)

# *Ten*

# PRESERVING THE PAST

The concept of a museum to preserve and protect the artifacts and memorabilia of Cheyenne's frontier celebration began in 1978. Various structures served as museum quarters, and in 1991 the Vandewark Wing was added, providing a modern showplace for the collection. Those folks participating in the ground-breaking ceremony, from left to right, are Shirley Flynn (museum director), Marietta Dinneen (board member), Jerry Carter, Wayne Brown, and Cheyenne mayor Gary Schaeffer. (Courtesy of OWM.)

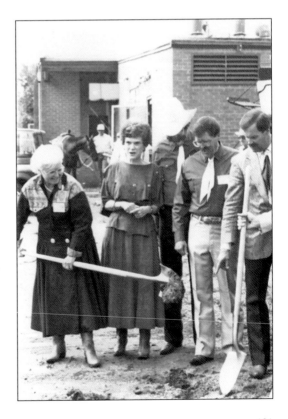

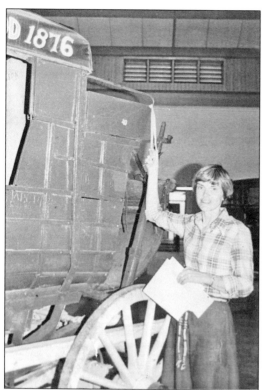

Marietta Dinneen is shown here in 1978 with an original Cheyenne-Deadwood Stagecoach that became part of a renowned vehicle collection at the Cheyenne Frontier Days™ Old West Museum. The coach was retired from stage service in 1881, and C.B. Irwin used it in his Wild West Show until 1917. It appeared in the Cheyenne frontier parades until it was retired in 2010. (Courtesy of OWM.)

Shirley Flynn was a founding board member of the museum in 1978, served as publicity chairwoman, and was named director of the museum in 1987. She retired in 1991 to devote her time to research and writing. Flynn is pictured here with the restored historic "Carey Mail" carriage. The vehicle belonged to Joseph Carey, Wyoming governor from 1911 to 1915. (Courtesy of OWM.)

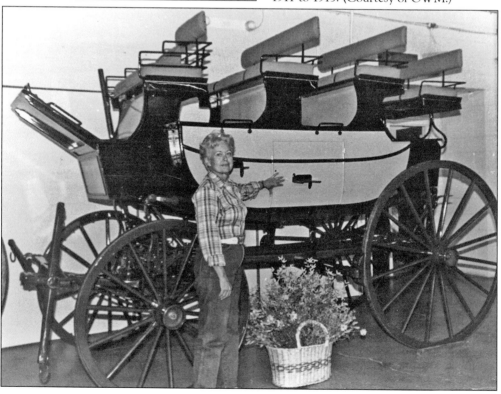

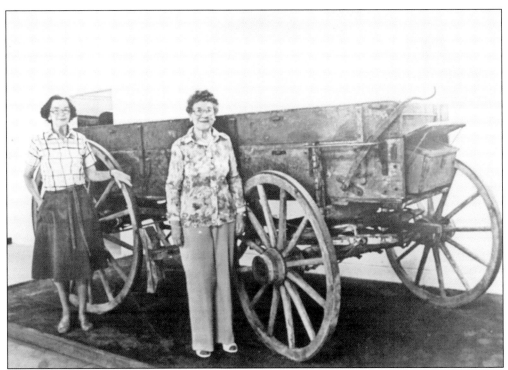

Volunteers known as "wagon doctors" painstakingly restore each carriage. The wagon doctors work year-round to restore the horse-drawn carriages and wagons as close as possible to their original condition. Mary Liz Carpender and Enid Lummis are shown here with a Studebaker Mountain Wagon from around 1880, a vehicle much in need of a wagon doctor. (Courtesy of OWM.)

Carriages arrive with certain degrees of wear and tear. It can take volunteers up to a year to conduct research and repair the priceless vehicles. Mary Liz Carpender, Marietta Dinneen, and Bill Schrader are pictured here with a Hansom Cab. (Courtesy of OWM.)

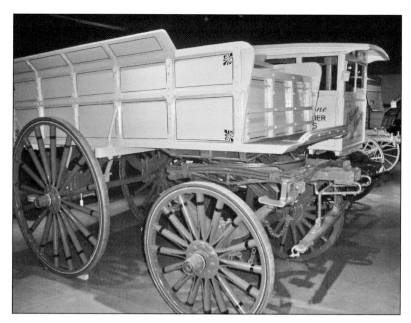

Most everything was moved by horse-drawn vehicle before the age of the automobile. This restored express wagon is an example of the type of vehicle used to transport freight in the early days of the settlement of the West. (Courtesy of Starley Talbott.)

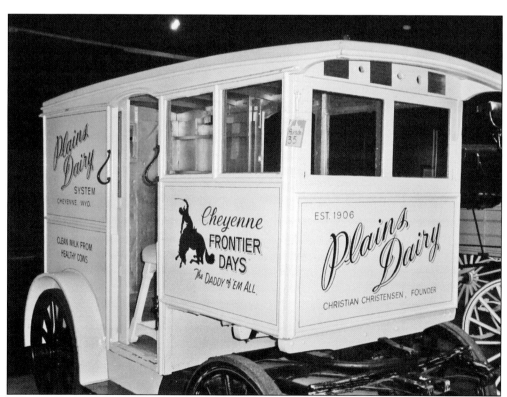

A milk wagon like this one was used by the Plains Dairy to deliver milk to Cheyenne residents. The dairy, founded in 1906 by Christian Christensen, was established on the family homestead northeast of the capital city. The business was moved to Cheyenne in 1929 and continued operations there until 1969, when it was sold to Dairy Gold. (Courtesy of Starley Talbott.)

This 1895 ice wagon was used to carry huge cakes of ice, sawed from frozen lakes such as Sloans Lake in Cheyenne. Ice was stored in sawdust to prevent thawing and then delivered door-to-door during the summer. Purchases were cut to order and weighed on scales at the rear of the wagon. (Courtesy of Starley Talbott.)

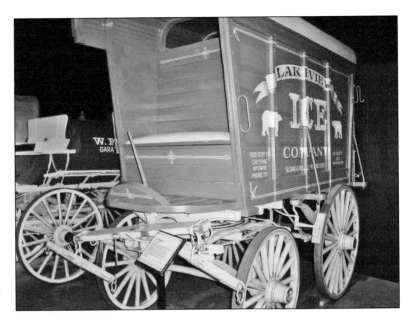

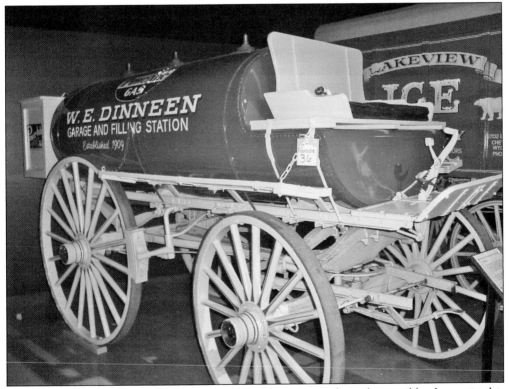

The W.E. Dinneen Garage and Filling Station in Cheyenne used an oil wagon like the one in this c. 1915 photograph to deliver gasoline and kerosene to its customers. The products were loaded into divided chambers in the tank from the top, and were then dispensed into containers through hoses in the back of the vehicle. A wooden storage box held cans of axle grease and lubricants. (Courtesy of Starley Talbott.)

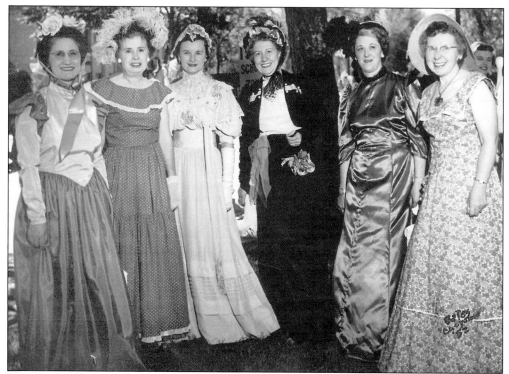

An additional aspect of the museum is the collection and preservation of historical clothing. Each year, vintage costumes that have been collected or constructed are modeled by participants. The W-Heels group has often sponsored a historical costume contest in conjunction with the frontier celebration. The women shown modeling their outfits in this photograph, from left to right, are Velda Schrader, Meda Lenhart, Virginia Kirst, Marie Lathrop, Janie Sibley, and Lois Bloomfield. (Courtesy of OWM.)

Today, the Cheyenne Frontier Days™ Old West Museum is considered a premier cultural and historical center. Educational programs are presented throughout the year, and exhibits exemplify the history of rodeo and the West. The museum features an annual world-class Western Art Show and Sale, an Interactive Children's Gallery, a Rodeo Champion Hall of Fame, and a prestigious collection of horse-drawn carriages and wagons. (Courtesy of OWM.)

# Bibliography

Flynn, Shirley E. *Let's Go, Let's Show, Let's Rodeo: The History of Cheyenne Frontier Days.* Cheyenne, WY: Wigwam Publishing Company, 1996.

Hanesworth, Robert D. *Daddy of 'Em All: The Story of Cheyenne Frontier Days.* Cheyenne, WY: Flintrock Publishing Company, 1967.

Larson, T.A. *History of Wyoming.* Lincoln, NE: University of Nebraska Press, 1978.

Riske, Milt. *Cheyenne Frontier Days: "A Marker from Which to Reckon All Events."* Cheyenne, WY: Frontier Printing, 1984.

Van Pelt, Lori. *Capital Characters of Old Cheyenne.* Glendo, WY: High Plains Press, 2006.

Weidel, Nancy. Images of America: *Cheyenne 1867–1917.* Charleston, SC: Arcadia Publishing, 2009.

# DISCOVER THOUSANDS OF LOCAL HISTORY BOOKS
## FEATURING MILLIONS OF VINTAGE IMAGES

Arcadia Publishing, the leading local history publisher in the United States, is committed to making history accessible and meaningful through publishing books that celebrate and preserve the heritage of America's people and places.

Find more books like this at
**www.arcadiapublishing.com**

Search for your hometown history, your old stomping grounds, and even your favorite sports team.

Consistent with our mission to preserve history on a local level, this book was printed in South Carolina on American-made paper and manufactured entirely in the United States. Products carrying the accredited Forest Stewardship Council (FSC) label are printed on 100 percent FSC-certified paper.

MADE IN THE USA